Peter Henry Emerson and American Naturalistic Photography

Peter Henry Emerson and American Naturalistic Photography

CHRISTIAN A. PETERSON

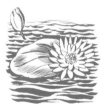

2008

MINNEAPOLIS INSTITUTE OF ARTS

This publication was produced in conjunction with the traveling exhibition

Peter Henry Emerson and American Naturalistic Photography.

Minneapolis Institute of Arts
Minneapolis, Minnesota
May 3–September 7, 2008

Palmer Museum of Art
Pennsylvania State University
University Park, Pennsylvania
January 20–May 17, 2009

Art Museum of Western Virginia
Roanoke, Virginia
June 14–August 16, 2009

Editor: Chris Keledjian
Graphic Designer: Mike Tincher, T DESIGN, Minneapolis
Photographer: Charles Walbridge
Publishing & Production Management: Jim Bindas, Books & Projects LLC

Photographs by Alfred Stieglitz
© Georgia O'Keeffe Museum /Artists Rights Society (ARS), New York

© 2008 Minneapolis Institute of Arts
2400 Third Avenue South
Minneapolis, Minnesota 54404
www.artsmia.org

Distributed by University of Washington Press
P.O. Box 50096
Seattle, WA 98145-5096
www.washington.edu/uwpress

Library of Congress Control Number: 2007941103
ISBN: 978-0-91296-498-0

Cover: **Henry Troth**, *In Springtime, Pennsylvania*, c. 1900, platinum print, Minneapolis Institute of Arts, McClurg Photography Purchase Fund

Contents

Acknowledgments

THIS PUBLICATION AND THE EXHIBITION it accompanies relied on the expertise and help of many individuals to whom I am grateful. I must first acknowledge Mack Lee, of the Lee Gallery in Winchester, Massachusetts. Mack amassed a major inventory of work by American naturalistic photographers, convinced me of the importance of the movement, and provided the majority of the photographs the Minneapolis Institute of Arts purchased for the project. Equally insightful was Mary Panzer, now an independent curator, who, back in 1982, organized an exhibition and wrote a catalogue on the Philadelphia naturalistic photographers for the Yale University Art Gallery. These two scholars laid the essential groundwork that made our exhibition and this book possible.

For information, insights, research assistance, and other materials, I express my gratitude to Michelle Anne Delaney, Paul T. Eitel, Jr., Anne M. Field, Suzanne L. Flynt, Ellen Handy, Paul M. Hertzmann, Charles Isaacs, Britta Karlberg, Carolee Michener, John-Michael Muller, Helen Eitel Rollins, Richard T. Rosenthal, Rachel Stuhlman, and David Winter.

I acknowledge other individuals and institutions whose input was important. The generous lenders to the exhibition are Mary Weston DeNucci, the Theodore Eitel Family, Anne M. Field, Dan Shogren, the Philadelphia Museum of Art, J. Paul Getty Museum, and the Princeton University Art Museum. Harry M. Drake's financial support was essential to the project, as his McClurg Photography Purchase Fund was used to buy most of the naturalistic photographs the museum acquired. Chris Keledjian sensitively edited my manuscript, and Mike Tincher provided the inspired design of this publication. In addition, I thank Jenny Jenkins for her devoted companionship.

At the Minneapolis Institute of Arts I thank the late Carroll T. Hartwell, former curator of photographs, and William M. Griswold, former director, for their support of the project. Laura DeBiaso provided essential logistical help, Jennifer Starbright handled the many details of object registration and exhibition travel, Charles Walbridge expertly photographed the originals for reproduction, and Patti Landres carefully matted and framed the pieces for exhibition. I also express my appreciation to the many other devoted staff members who contributed to the success of this catalogue and exhibition.

Christian A. Peterson
Acting Curator of Photographs

Peter Henry Emerson and American Naturalistic Photography

IN 1889 ENGLISHMAN PETER HENRY EMERSON published his book *Naturalistic Photography for Students of the Art*, defining a new style of camera work and making a case for photography as an art. To this end, he advocated nature as inspiration and subject, simple compositions, and differential focusing. Emerson believed that Nature (frequently capitalized in his writings) was the sole source and standard for photographic art. He advised creatively inclined photographers to make images that read as one harmonious whole by choosing a single point of interest and downplaying all surrounding detail. Most importantly, he introduced the idea of sharply rendering only the primary subject of an image and making everything else slightly out of focus, an approach he thought mimicked normal human vision.

Though widely debated, naturalistic photography quickly caught on in Britain and soon made its way across the Atlantic to the United States. Alfred Stieglitz and others in the first generation of American art photographers admired Emerson's sensitive images and absorbed his revolutionary theories. Naturalistic photography was, in fact, the first movement of creative photography in this country, preceding and overlapping the more well-known school of pictorial photography. However, to date, American naturalistic photography and Emerson's influence on it have been little acknowledged.[1]

Emerson's Early Life and Introduction to Photography

P. H. Emerson was born in 1856 in Cuba, to an American father and English mother. The senior Emerson owned a sugar plantation in Cuba and was a fourth cousin of the American writer Ralph Waldo Emerson. Peter Henry's family moved back and forth between Cuba and the United States a few times, but in 1869 his mother relocated them permanently to England after the death of her husband. Emerson grew up among the privileged elite and benefited from an independent income throughout his life. He became a typical Renaissance man of the period, accomplished as an athlete, scientist, naturalist, physician, artist, and photographer.

Emerson became interested in photography in about 1881, buying

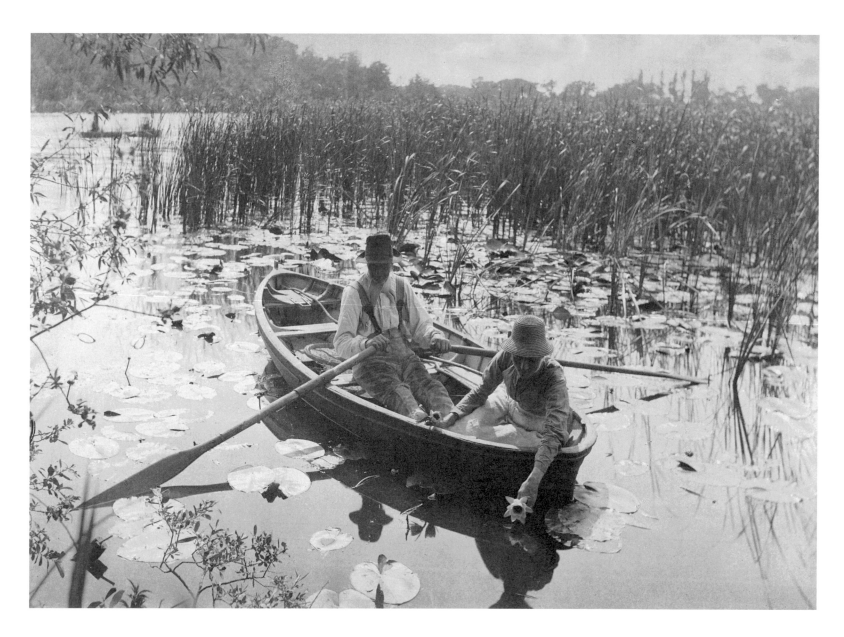

1. | **Peter Henry Emerson**
Gathering Water Lilies
1886, platinum print, Minneapolis Institute of Arts, McClurg Photography Purchase Fund

his first camera, studying with a well-known university chemistry professor, and exhibiting his work at the Photographic Society of Great Britain (soon renamed the Royal Photographic Society). Between 1886 and 1895 he issued two deluxe portfolios and six books, the first of which, *Life and Landscape on the Norfolk Broads*, included a platinum print of *Gathering Water Lilies* (fig. 1). This picture, now Emerson's signature image, perfectly sums up the tenets of naturalistic photography in its natural subject, simple composition, and use of differential focusing. It was so widely admired at the time that many photographers produced their own versions of it, in clear homage to the master of naturalism in photography.

Emerson's philosophy and work were, in large part, a conscious reaction against the reigning style of artistic photography in England during the 1860s and 1870s. The pictures of this earlier generation of photographers, led by Henry Peach Robinson, were distinguished by their allegorical subjects, overall sharp detail, and composite printing technique (using more than one negative). Among the most renowned of these images was Robinson's *Fading Away* (fig. 2), a moralizing pastiche inspired by academic genre painting and sewn together from five different negatives. Emerson considered such work contrived, unnatural, saccharine, and damaging to the cause of photography as an art form. For years, he and Robinson sparred relentlessly in the photographic press, neither yielding his position nor ultimately seeing his outlook dominate the field.

Publication of *Naturalistic Photography*

Emerson first outlined his ideas on naturalistic photography at a March 1886 meeting of the Camera Club of London, but his book on the subject was not published until three years later. Issued by the prestigious London house Sampson Low, Marston, Searle and Rivington, it received widespread attention and reviews. R. Child Bayley, the editor of *Amateur Photographer*, called it a "bombshell dropped at a tea party," noting that Emerson's concept of

differential focusing was the hottest topic. It soon became clear, however, that many photographers misunderstood the concept, thinking that Emerson was advocating throwing one's entire picture out of focus, an idea that was heresy to those who believed that one of the strengths of the medium was to render images in crisp, sharp detail. Ironically, overall soft-focus effects were soon embraced by the subsequent generation of artistic photographers—the pictorialists—whose work Emerson never came to appreciate.

The three hundred dense pages of *Naturalistic Photography for Students of the Art* comprised three major sections of about equal length. The first included the author's definition of terms, his subjective history of world art, and his ideas on the phenomenon of human sight. The second was a detailed account of photographic technique, ranging from the exposure of plates to the mounting of prints. And the last section covered photography as an art in terms of composition, subject matter, and decorative quality. Significantly, the book was unillustrated. By 1889 Emerson had published the majority of

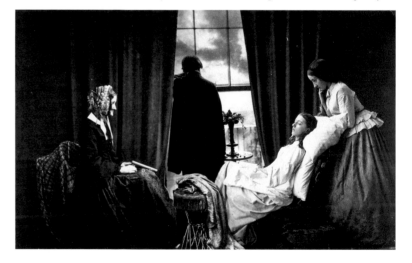

2. | Henry Peach Robinson
Fading Away
1858, albumen print, George Eastman House, gift of Alden Scott Boyer

his illustrated volumes, all of which sold out quickly, despite their high prices (due to their overall high production quality and the exquisite beauty of their photogravure plates).

Perhaps Emerson wished that his words would carry the full weight of his argument and that the book be more affordable than his others. Indeed, the first edition of *Naturalistic Photography* sold out in three months. A second edition was issued in 1890, this time by an American publisher as well. There were very few changes to the text, but the publishers made sure to include excerpts from more than ten positive reviews of the first edition, from four different countries.

Nature as Muse

Emerson made it clear in both *Naturalistic Photography* and his earlier volumes that nature was the sole fountainhead of all creative expression. In 1887 he asserted, "All we ask is that the results shall be fairly judged by the only true standard—NATURE—and the only knowledge required by the public for a true and thorough appreciation of pictures is a knowledge of Nature, which can only be obtained by studying her."[2] He believed that rural life and the landscape were the only legitimate subjects for artistic photography. Nature was simultaneously the single thing that photographers should turn their camera upon and the single principle they should use to judge their results. "Wherever the artist has been true to nature, art has been good," he wrote, and "wherever the artist has neglected nature and followed his imagination, there has resulted bad art."[3]

Emerson, however, was not a visual realist. He did not believe that cold transcriptions of nature made for art; instead he regarded the registration of the bald facts of a place as mere topographical work. In *Naturalistic Photography* he gave a succinct, one-sentence definition of naturalism: "By this term we mean the true and natural expression of an impression of nature by an art."[4] For him a successful naturalistic photograph did not have the full range of tones common to utilitarian photographs but the correct relative tonalities of a scene as experienced by a sensitive observer.

Nature was not an easy study or quick read. Emerson advised photographers that they had to engage the rural lifestyle at length in order to understand and appreciate its beauties and meaning. He wrote, "The student who would become a landscape photographer must go to the country and live there for long periods; for in no other way can he get any insight into the mystery of nature."[5] He advised photographers to spend enough time in the wild to comfortably identify themselves as a part of their environment.

Emerson practiced what he preached, learning about nature by living in it as a true outdoorsman. He spent extended periods away from his family, photographing and writing about the coastal waterways of Norfolk and Suffolk counties, northeast of London. He helped found rowing teams and was active in yacht and sailing clubs. He owned his own sailboat, on which he took a near yearlong cruise with T. F. Goodall, a naturalistic painter and close collaborator. "But Emerson's real companions, most real, most close, were the wind, the light, the sky, and the waters," according to his first biographer, Nancy Newhall.[6] Not surprisingly, he kept detailed logs on this trip that recorded the daily weather conditions and sightings of fish and fowl. And he produced understated photographs that captured the quiet mood of the prosaic places he encountered (fig. 3).

Mother Nature for Emerson did not entail grandiose land formations, exotic people, or faraway wonders of the world. Instead, he was happy with the simple landscape and everyday inhabitants of rural England. He preferred to engage these subjects alone (or with Goodall) as an interested traveler, not as part of an opportunistic group of tourists. He found solace, integrity, truth, and beauty in the common life and labor of the underprivileged folk of this idyllic rural world. These peasants were the very bedrock of England's southeastern broads. Though they lived under difficult conditions, Emerson always portrayed them as noble and courageous individuals (fig. 4).

Emerson engaged his subjects on a very personal level, but he

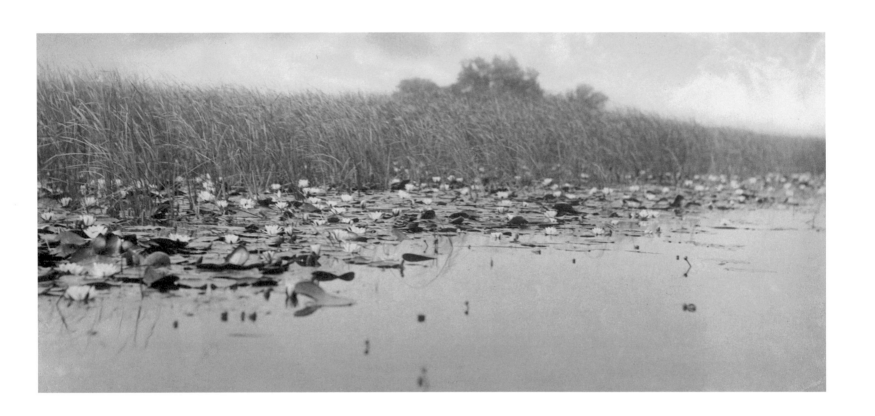

3. | Peter Henry Emerson
Water Lilies
1886, platinum print. Minneapolis Institute of Arts, McClurg Photography Purchase Fund

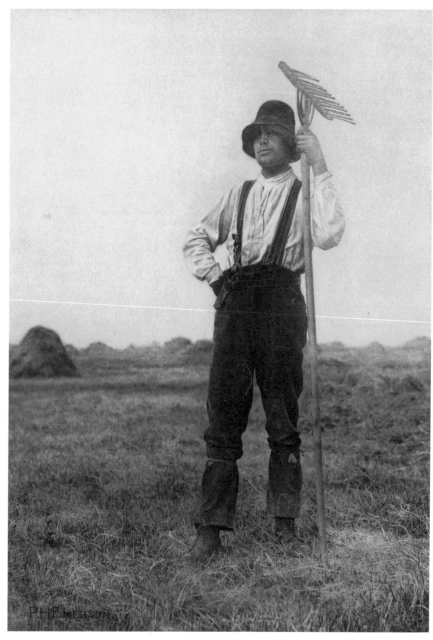

4. | Peter Henry Emerson
Haymaker with Rake
1886, photogravure, Minneapolis Institute of Arts, McClurg Photography Purchase Fund

preferred to photograph them as universal types. He advised, "One thing you must never forget, that is the *type*; you must choose your models most carefully, and they must without fail be picturesque and typical. The student should feel that there never was such a fisherman, or such a ploughman, or such a poacher, or such an old man, or such a beautiful girl, as he is picturing."[7] This approach removed his images from the realm of individual portraiture and made them universal.

Emerson wrote extensive texts for all of his illustrated publications, sometimes with Goodall's assistance. Largely separated from his images today (due to the market for his prints, which have been frequently extracted from his books), these writings reveal Emerson to be as much an anthropologist as a photographer. In the preface to *Pictures of East Anglian Life* (1888), the author himself admitted that he was attempting a "Natural History of the English Peasantry and Fisherfolk." The specificity of Emerson's texts contrasts strongly with the generic quality of his images. The same book, with 150 pages of text, featured chapters on Character and Intelligence, Religion, Superstitions, Witchcraft, Ghost Stories, Medicine, Politics, Habits and Customs, Business Dealings, Landlord Relations, Poaching, Smelting, Eel-Picking, Shrimping, Harvesting, Basketmaking, Brickmaking, Fencing, Gardening, and numerous other topics. In addition, the text gained great immediacy by frequently being written in the present tense and being spiced with examples of local dialect.

Emerson was an unapologetic conservationist. He complained about the near extinction of several species of rare birds because of over hunting and in one book included ornithological information on hundreds of examples. In fact, during the 1880s, when Emerson spent time in the Norfolk Broads, the region suffered from increased encroachment of modern civilization. The rustic, Arcadian, pastoral Old World he so loved was slipping away, being drained of much of its authenticity just as the marshes were of their water.

Differential Focusing

Nature was clearly Emerson's primary guiding principle in making photographic art. Second in importance among his aesthetic considerations was his theory of differential focusing. Inspired in part by Herman von Helmholtz's *Handbook of Physiology Optics*, Emerson believed that the human eye saw things sharply only at the center of our vision. "The rule of focusing," he stated in *Naturalistic Photography*, "should be, focus for the principal object of the picture, but all else must not be sharp" (page 119). Photographs should be clear, detailed, and finished in the center, whereas the rest of the image should be suggestive and subdued. Emerson emphatically cautioned, however, that the outer planes of a picture should not descend into fuzzy, indistinct areas where the structure of the subject was destroyed. Such areas were to function as an integrated backdrop for the primary subject, not as an arbitrary scrim of undifferentiated tones and values. Furthermore, Emerson declared that the way our eyes viewed the world was the way naturalistic photographers should render their images. "Our contention is that a picture should be a translation of a scene as seen by the normal human eye," he wrote (97). To him, this made the most sense because it was literally the most "natural" way to create artistic images with the camera.

Compositional Simplicity

Emerson believed strongly in simple composition and devoted a full chapter to it in *Naturalistic Photography*. However, he warned his readers not to adhere too closely to the so-called rules of composition. Students should be well versed in the principles of how to coherently compose a picture but not slavishly follow them. Emerson defined composition in a somewhat roundabout manner as "the harmonious and fitting combination of the various component parts of the picture which shall best express the picture"(238). For photographers, composition was largely a matter of selection, that is, deciding how much of a

scene to take in. And, generally speaking, the less the better. Writing in Emerson's first book, Goodall recommended crafting simple compositions and avoiding the common error of including too much—often enough material for two or three separate pictures. This was exactly what Emerson's nemesis H. P. Robinson often did, as a result of his piecing together his photographs from multiple, disparate sources.

If photographers used nature as their guide, utilized differential focusing, and made simple compositions, Emerson was convinced they would make art. Such workers did not copy or imitate nature but interpreted it. He pointed out, "Nature does not jump into the camera, focus itself, expose itself, develop itself, and print itself. On the contrary, the artist, using photography as a medium, chooses his subject, selects his details, generalizes the whole the way we have shown, and thus gives *his* view of nature" (284). Emerson delineated the vast difference between science and art. He observed that the former depended on a multitude of facts and the intellect, while the latter was manifest by interpretation and emotion. Emerson even maintained that photography was the best monochrome process for making art. In *Naturalistic Photography* he discussed the strengths and weaknesses of drawing and the various graphic arts. "Now we come to photography, which possesses a technique more perfect than any of the arts yet treated on. Photography, in fact, stands at the top of the tone class of methods of expression; so nearly perfect is its technique that in some respects it may be compared with the colour class" (277).

Emerson's Artistic Influences

Not surprisingly, Emerson drew inspiration from the other arts for his photographic work. As mentioned previously, he was a close friend of the English painter Goodall, with whom he shared subject matter and outlook. He corresponded with James McNeill Whistler, whose work he admired for its suppression of detail, and he even sent Whistler a copy of his portfolio *Pictures of East Anglian Life*. Emerson wrote extensively on the history of painting,

from the Renaissance to the present, judging artists solely on their adherence to nature. As far as he was concerned, plein air painters were the only ones worth considering.

Emerson was most drawn to the work of the French Barbizon painters of the early nineteenth century. This romantic school set the ideal precedent for naturalistic photography in its emphasis on landscapes and peasant scenes rendered in low tones and softened atmosphere. Emerson frequently referred to the leading Barbizon artists, Jean-Baptiste-Camille Corot (1796–1875) and Jean-François Millet (1815–75), in his publications **(fig. 5)**. "A master good

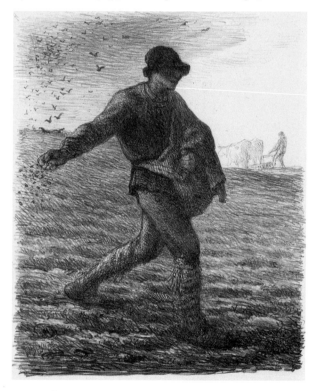

5. | Jean-François Millet
The Sower
1851, lithograph, Minneapolis Institute of Arts, gift of Herschel V. Jones

for all time" is how he characterized Corot in *Naturalistic Photography*. "His later work is true and great. Full of breadth and feeling for the subtleties and poetry of nature, he has never been surpassed" (85). In the same book, Emerson declared that "everything about J. F. Millet the Great is worthy of study. Let the student seize every chance of studying his works.... Here is directness of expression never surpassed" (86). He then went on to include four pages of quotations by Millet, all of which bolstered Emerson's worship of nature. The words of Corot were also immortalized by Emerson, appearing on the title pages of several of his publications. The ultimate compliment was paid to Emerson himself when a review of his 1888 book *Pictures of East Anglian Life* favorably compared his pictures of peasants to those of Millet.

Platinum Printing and Photogravure

Though Emerson's artistic idols worked primarily in color and on canvas, he was content to create in monochrome and on paper. He utilized and championed the two leading processes strongly preferred by creative photographers at the end of the nineteenth century, the platinum print and photogravure.

Platinum prints yield a long tonal range, including deep blacks and subtle middle values. Platinum paper became commercially available in about 1880 and quickly replaced albumen paper for artistic work. Whereas albumen prints were generally brown toned, glossy, and crisp, platinum prints were more neutral, matte surfaced, and somewhat diffused. Emerson had used both techniques when he began exhibiting but soon set on platinum as his medium. "We emphatically assert that the platinotype process is *facile princeps*," he wrote, because he considered other papers to render false tones and less permanent prints (191). Emerson illustrated his first book, *Life and Landscape on the Norfolk Broads*, with forty exquisite original platinum prints. Today the book is considered his magnum opus and one of the world's most important photographically illustrated volumes of the nineteenth century.

Emerson turned to the photogravure process to provide the images for all his subsequent publications. Between 1886 and 1895 he issued two portfolios and six books with photogravure plates. This intaglio technique, devised in 1879, produces photographic images printed on a press in ink, like etchings and engravings. Serious photographers favored photogravures because, similar to platinum prints, they featured deep blacks and subtle mid-tones. The process was labor-intensive, as every gravure was printed by hand, one by one. After a print was made the plate had to be cleaned, reinked, and put through the press again. In 1890 Emerson declared that "the artist who works in photography must not rest until he has mastered photo-etching [photogravure]: then he is completely equipped, and ranks with the etcher."[8] He personally learned the process from W. L. Colls, England's leading practitioner of photogravure, then went on to etch the plates and print all the gravures that appeared in his subsequent books. He asserted that photogravure was "the only satisfactory way of publishing photographs."[9]

The Death of Naturalistic Photography

In 1890 Emerson once again shook the international photographic community when he dramatically issued a pamphlet titled *The Death of Naturalistic Photography*. This black-bordered, eight-page tract reversed his assertion that photography was an art. In it, he told readers that he now believed that photographs were rendered by mechanical methods, not the personal means essential for artistic creation. "The limitations of photography are so great," he wrote, that the "individuality of the artist... can hardly show itself."[10] Emerson changed his attitude about photography largely because the scientific team of Hurter and Driffield had just proven that photographers could not control the relative values of their images, thus compromising their creative control of the medium. While Emerson stopped proselytizing for photography as an art, he nonetheless continued to produce, publish, and exhibit images that looked like his earlier work.

In 1899 a third edition of *Naturalistic Photography* appeared (in both London and New York again), with text that reflected his new feelings about photography not being an art. But the example of Emerson's work and his ideas about differential focusing and nature as inspiration and standard remained strong both at home and abroad. In the United States, Emerson's *Death of Naturalistic Photography* did not persuade photographers to stop making partially diffused landscape images in the naturalistic style. In fact, American naturalistic photography thrived for a few decades, based on Emerson's straightforward and simple precepts. Some American photographers drew direct inspiration from Emerson and some absorbed his sensibilities more vicariously. In any event, American naturalistic photography developed into a widespread and significant movement that paid homage to its towering English progenitor, Peter Henry Emerson.

Emerson's Work and Words in America

Art-minded photographers were exposed in this country to Emerson's work and ideas by various means. He exhibited in the United States, had his books published and reviewed here, and himself wrote for the American photographic press.

As far as is known, Emerson's work was first shown in this country at the American International Exhibition of Photography, in Philadelphia, during January 1886. This massive exhibition featured over seventeen hundred photographs by more than one hundred contributors from seventeen different countries. Sponsored by the Photographic Society of Philadelphia (PSP) and hung at the prestigious Pennsylvania Academy of Fine Arts, it was the most artistic display of photographs yet seen in the United States. Emerson contributed at least four platinum prints, including such typical ones as *Baiting the Lines* and *A Suffolk Marsh*. The *Philadelphia Photographer* observed that his entire display helped "to show the versatile talent of Mr. Emerson and give a refreshing variety of subjects to his admirers."[11] At the close of the exhibition,

the PSP acquired work for its budding permanent collection of photographs from only three exhibitors, one of whom was Emerson, who generously donated his entire exhibit. This set of images provided inspiration for years to members of the PSP, one of the country's leading incubators of naturalistic photography.

The very next year, Emerson once again sent work to the United States, this time for the first Joint Exhibition. The Joint Exhibitions were a series of shows cosponsored by the country's leading camera clubs—the PSP, the Boston Camera Club, and the Society of Amateur Photographers of New York—who took turns presenting them in their respective cities. The 1887 exhibition was hung in New York, where critics particularly noted the strength of the English material. Among the magazines that reviewed the show was the *Philadelphia Photographer*, which, in its April 16 issue, declared that Emerson's name was "already known" in this country. His entries included eight-by-ten-inch platinum prints, for which he won a diploma, and a photogravure of *Gathering Water Lilies* (fig. 1).

Emerson also participated in the third Joint Exhibition of 1889, which was held in Philadelphia. There he contributed twenty portrait and landscape pictures of excellent merit. According to *Anthony's Photographic Bulletin*, "Dr. P. H. Emerson, of Chiswick, London, had a fine collection of photogravures of his beautiful studies, each one artistic, and telling in the most perfect manner the story they were intended to relate. Some few were pictures of scenery; these also were beautiful and very artistically caught."[12]

Naturalistic Photography was widely and positively reviewed in American periodicals, even though the first edition was published only in London. It received notice in at least six photographic magazines, making it difficult for any serious photographer, amateur or professional, to miss hearing about it. Among them were *American Amateur Photographer* (Brunswick, Maine), *American Journal of Photography* (Philadelphia), *St. Louis and Canadian Photographer* (St. Louis), and *Wilson's Photographic Magazine* (New York). *Anthony's Photographic Bulletin*,

published in New York, chose to review it twice, once by its English correspondent and once by someone in the home office. The domestic writer ended his review by declaring that "any photographer who cares anything about his art other than mere bread-winning will find the volume full of practical suggestions that will delight him, and show the steps to a higher level in artistic photography."[13] The *Photographic Times* (New York) likewise reviewed it twice. One of their writers, W. J. Stillman, treated it in such depth that his review was spread over three separate issues. In addition, mainstream periodicals also recommended *Naturalistic Photography*. These included *Cosmopolitan* and *Scientific American*. The latter gushed: "This book contains a greater amount of information on the artistic elements to be considered in photography than any that we know of."[14]

In 1890, when Emerson issued the second edition of the book and his melodramatic pamphlet *The Death of Naturalistic Photography*, many of the same American periodicals enthusiastically reported on them. And when the third and final edition of *Naturalistic Photography* was published in 1899, the title once more received significant attention. The *Photographic Times* again reviewed it twice, and the *American Amateur Photographer*, now the country's leading photographic monthly, similarly touted it. "It may be read with both pleasure and profit," according to the latter, and "it should be carefully studied by every photographer who aims at something higher than 'the usual thing.'"[15]

First, second, and third editions of *Naturalistic Photography* found their way into countless private and institutional libraries in the United States. Not surprisingly, the Camera Club of New York, the nation's leading group of artistic photographers, listed two copies of the book in its 1902 library catalogue. Stieglitz, who happened to be a member of this club, personally owned at least two editions. And individuals far from the Northeastern hub of camera club activity also picked up copies for themselves. Among them was Theodore Eitel, a naturalistic photographer in Louisville, Kentucky, who cited Emerson's book in an article he wrote in 1910 on photographing trees.

He asserted that "the student's insight into the vast subject of composition will be materially aided by study" of the book.[16]

Glowing reviews of Emerson's other publications appeared as well in American magazines, spreading his name among both photographers and the general public. New York's *Nation* was delighted with his 1888 book *Pictures of East Anglian Life*, writing that "no one can study the illustrations and read the accompanying text without becoming imbued with the author's enthusiasm, and without feeling that he has gained an entirely new insight into the character and surroundings of the English peasant. So artistic are the illustrations, with their Corot-like softness of outline, that in future no book that deals with an unfamiliar country will seem complete without such aids."[17] The *American Amateur Photographer* gave the book a full-page review.

Nation subsequently praised *Wild Life on a Tidal Water* (1890), noting the "delicacy of observation and truth of rendering, together with a certain sentiment of the landscape hard to characterize."[18] This title was also heralded by *Anthony's Photographic Bulletin*, for both the beauty of its illustrations and the power of its writing. In 1891 *St. Louis and Canadian Photographer* reviewed the portfolio edition of Emerson's *Pictures of East Anglian Life*. And Emerson's images continued to be reproduced in American periodicals throughout the decade. The *Photographic Times*, for instance, featured his work in 1894, 1895, and 1896.

Emerson, a prolific writer as well as image maker, was not content to leave the American press to their own writers. He penned his own, highly opinionated articles for numerous photographic periodicals here throughout the 1890s. The first appeared in the *American Amateur Photographer* as "Our English Letter," a column that ran from September 1889 to March 1890. In it Emerson reported on English journals, conventions, exhibitions, and photographers. He praised the portraits of Julia Margaret Cameron and continued his sharp criticism of the work of Henry Peach Robinson. He happily observed the increased use of photogravure and platinum printing, his favorite mediums. In an article he wrote on the annual London

exhibition of the Photographic Society of Great Britain, he applauded the reduction of sharp focusing, artificial compositions, and combination printing. "The exhibition, as a whole, is markedly interesting as showing the great strides made in artistic photography during the last five or six years, and after a careful survey of all the pictures, the one lesson that it teaches is the *complete triumph of naturalism.*"[19]

The very month that Emerson stopped contributing to *American Amateur Photographer*, another periodical, *Photographic Times*, began a serialization of *Naturalistic Photography*. Over the course of the next nine years, the text from virtually the entire book ran in its pages, although sections were taken from different editions. Nearly forty issues of the magazine featured portions of Emerson's most important essay, in 1890, 1893, and 1896–99.

Other photographic periodicals also ran articles by Emerson or quoted him. In 1891 fellow photographer George Davison cited Emerson's maxim "Nature will never go out of fashion," in an article in *Wilson's Photographic Magazine.*[20] A few years later the same magazine included Emerson's definition of naturalistic photography in an unsigned three-page article.[21] The *American Annual of Photography 1895* ran Emerson's full-blown essay "What Is a Naturalistic Photograph?" And in 1900, three American magazines reprinted his article "Bubbles," which originally had appeared in an English journal. This piece comprised Emerson's rantings against the gum-bichromate process, a new means of printmaking highly favored by pictorialists because of the manipulation it allowed. "Now it seems to me this 'gum' printing is one of the greatest bubbles floated upon the limpid stream of pure photography," wrote Emerson. "The gum process destroys tone, texture, and with it values and atmosphere; it makes the result coarse and false, and to look like the photograph of a painting."[22] This article ran simultaneously in *American Amateur Photographer*, *Photographic Times*, and *Wilson's Photographic Magazine*, which were read by thousands of photographers across the country. After this flourish of attention Emerson withdrew from publishing his images and writing about

photography, letting followers seek out his material on their own. Nonetheless, in 1909 the *American Annual of Photography* ran a full-page portrait of P. H. Emerson, Esq., acknowledging his pioneering work and enduring influence.

Emerson and Alfred Stieglitz

Emerson influenced the early work of Alfred Stieglitz, the individual who would do the most for American creative photography in the early twentieth century. Though Stieglitz spearheaded pictorial photography in this country and then went on to promote modernism, he began as a naturalistic photographer. Stieglitz took up photography while living in Europe in the late 1880s and then returned for visits in the 1890s. While there he photographed primarily the idyllic landscape and its rural inhabitants, in a style consistent with Emerson's aesthetic. In 1887 Stieglitz received his first award after entering an Italian genre scene in a competition sponsored by the English magazine *Amateur Photographer*. The contest was judged by none other than Peter Henry Emerson, who liked the spontaneity of Stieglitz's picture.

Stieglitz continued to produce classic naturalistic photographs for nearly another decade. In 1890 he made *Weary* (**fig. 6**), a sensitive image of a peasant girl resting after gathering wood for the family fire. The repose of the figure, the rural setting, and the selective focusing all would have pleased Emerson. Likewise with Stieglitz's image *Mending Nets* (**fig. 7**) of four years later. Stieglitz made a number of images of fisher folk at a coastal town in the Netherlands and claimed that this one was his favorite because of how it typified their very existence. "It expresses the life of a young Dutch woman; every stitch in the mending of the fishing net, the very rudiment of her existence, brings forth a torrent of poetic thoughts in those who watch her sit there on the vast and seemingly endless dunes, toiling with that seriousness and peacefulness which is so characteristic of these sturdy people. All her hopes are concentrated in this occupation—it is her life."[23] Just as Emerson investigated the lifestyle of the inhabitants of the Norfolk Broads, Stieglitz was

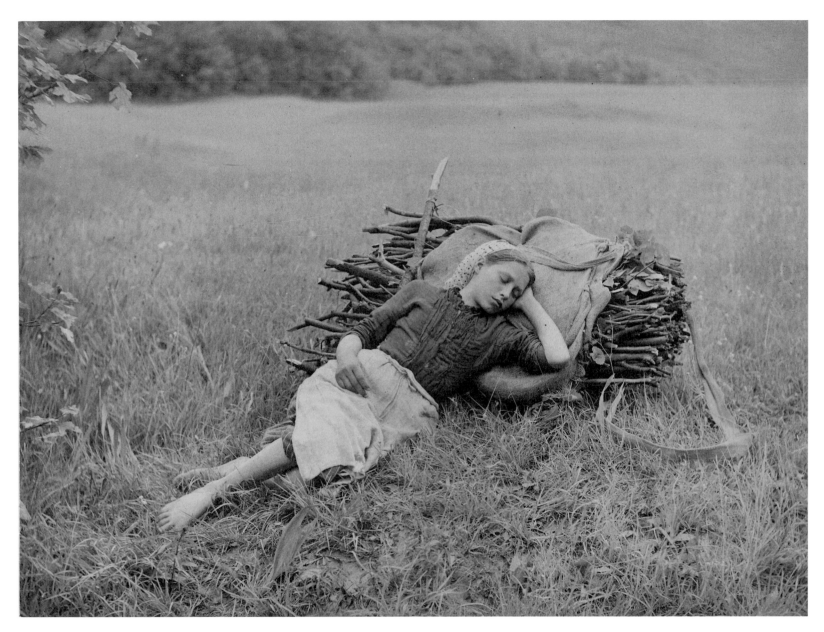

6. | **Alfred Stieglitz**
Weary
1890, platinum print, collection of Mary Weston DeNucci

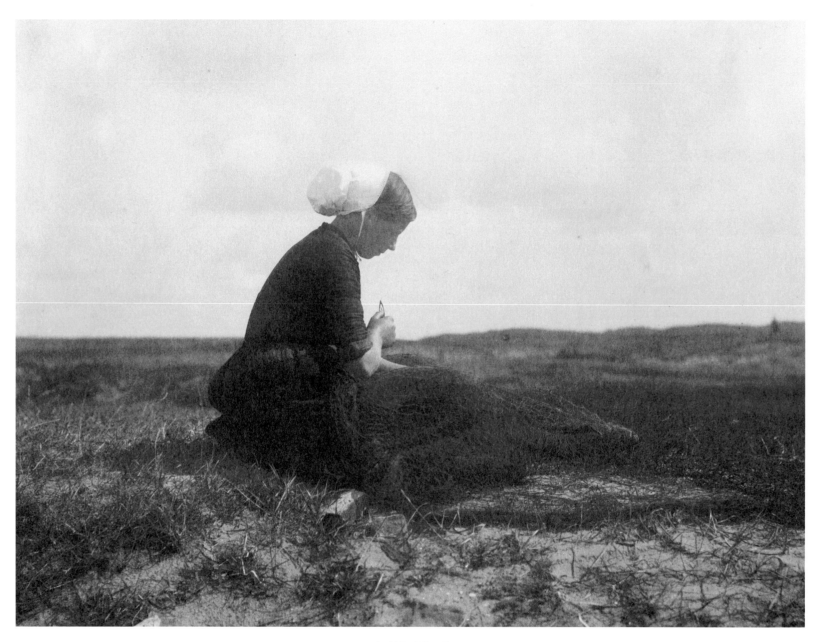

7. | **Alfred Stieglitz**
Mending Nets
1894, platinum print, Princeton University Art Museum, Fowler McCormick Fund

intent upon picturing typical activities of these particular Dutch subjects.

Emerson and Stieglitz admired each other's work and were in close contact during the late 1880s. Emerson first wrote to Stieglitz in 1888, beginning the letter, "Although we are unknown to each other in the flesh we are I trust friends in spirit."[24] He then asked Stieglitz to translate *Naturalistic Photography* into German, as Stieglitz was fluent in the language and was currently living in Berlin. Though they never found a German publisher for the book, the two wrote to each other regularly at the time. In 1889 Stieglitz reviewed a Berlin exhibition that included photographs by Emerson. "The crack exhibit," he proclaimed, "was undoubtedly some of P. H. Emerson's landscape work. Here is a man with great individuality and great originality, and one who has had the pluck to introduce naturalistic principles into the art of photography."[25] A few years later Stieglitz reviewed the 1893 Joint Exhibition in New York and similarly praised Emerson's contributions. When the third edition of *Naturalistic Photography* was published, Stieglitz favorably reviewed it in *Camera Notes*. He observed that the book was now "a classic in photographic literature" and encouraged his readers to study it seriously.[26] Stieglitz and Emerson met only once, in 1904, but Stieglitz was so feverishly ill at the time that he subsequently barely remembered the encounter. Emerson and Stieglitz corresponded for many years, from 1888 to 1933, maintaining a vital link between artistic photography in England and the United States.

Back-to-Nature Movement

American naturalistic photography was an element of the broad back-to-nature movement that swept this country in the late nineteenth century. During this period Americans moved in droves to the cities, and the Industrial Revolution significantly altered their lives. The middle class grew as factories spewed out new products in mass quantities, railroads provided greatly expanded transportation, and consumerism took hold in America. Soon, however, individuals began to realize that their spiritual, moral, and physical well-being was threatened by such "progress" and the dehumanizing effects of science and technology. So, they began to look to nature and folk culture for renewed personal enrichment. Whereas the previous generation considered the wilderness threatening and unsightly, this new one found it embracing, enlightening, regenerative, and beautiful.

The back-to-nature movement had its genesis in the writings of P. H. Emerson's relative Ralph Waldo Emerson, the poet Walt Whitman, and the naturalist Henry David Thoreau. It was Thoreau's book *Walden Pond* that was most influential, when it became popular after the author's death in 1862. Living alone for two years in a one-room shack on the edge of a small Massachusetts lake, Thoreau dealt with securing everyday necessities such as food, yet undertook a close, transcendental interaction with his natural habitat. He then wrote about his extraordinary "life of simplicity, independence, magnanimity, and trust." By the turn of the twentieth century Thoreau's example had spawned an overabundance of related writing: children were assigned nature-study textbooks in school, seniors turned nature romances into best sellers, and the general populace avidly read guidebooks, outdoor adventure stories, and magazines like *Outing* and *Field and Stream*.

Conservation and the Arts and Crafts aesthetic were tightly wrapped up in the back-to-nature movement. The original "tree-huggers" pressed for government to set aside vast tracts of virgin land, with Yellowstone becoming the country's first national park in 1872. Shortly thereafter John Muir founded the Sierra Club, today the country's leading environmental advocacy group. Under the progressive administration of President Theodore Roosevelt (1901–9) numerous federal agencies were established to protect the nation's waterways, forests, and other natural resources. Untold numbers of men, women, and children took up such nature activities as gardening, camping, hiking, fishing, hunting, and bird watching. At home they lived a simple, down-to-earth lifestyle and crafted unique items with their hands. Arts and Crafts participants inhabited warm and welcoming bungalows with open floor plans

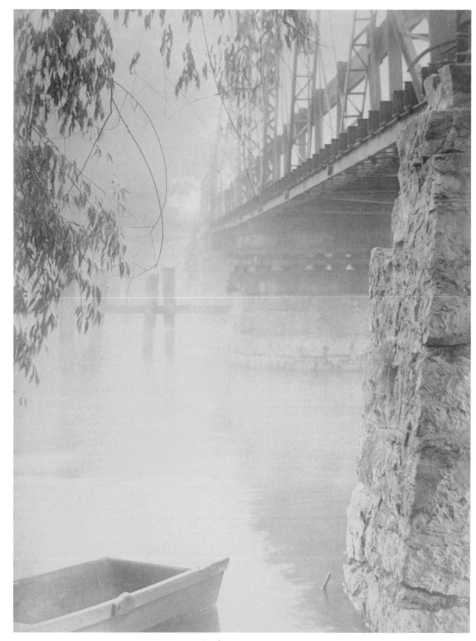

8. | J. H. Field
Spoor's Bridge

c. 1900, platinum print, collection of Anne M. Field

designed to integrate the interior with the surrounding yard. They delighted in making useful items like textiles and pieces of pottery, metalwork, and even furniture. Every utilitarian object was to be both well designed and aesthetically pleasing. Colonies and entire villages, such as Deerfield, Massachusetts, sprung up to nurture the concept of combining art with life.

Nature as Muse in American Naturalistic Photography

American naturalistic photographers embraced the primary precept of both the back-to-nature movement and Peter Henry Emerson: nature as muse. They believed that they should spend considerable time communing with nature and photographing her glories. They nurtured a real love of their subject by careful and deliberate study and by opening themselves up to its mysteries. Many of the naturalistic photographers grew up near rural areas that gave them easy access to unbridled nature in all seasons of the year. J. H. Field claimed that he spent all his spare time as a youth playing on the outskirts of his hometown (fig. 8). Likewise, Rudolf Eickemeyer, Jr., constantly explored the woods adjacent to his boyhood home and by his early twenties had begun a lifelong practice of hiking every weekend.

These and other photographers asserted that they could effectively picture nature only after becoming intimate with her ways and means. William Dassonville, who concentrated on misty landscapes early in his career, stated, "One who wishes to interpret nature must first go to nature and learn her forms and moods."[27] This allowed him to capture the quiet mood and spirit of the sites he chose to get to know with his camera (fig. 9). Theodore Eitel corroborated this sentiment. He wrote that "the photographer cannot effectively reproduce the trees he has before him, unless he understands their habits and their peculiarities. Trees and the woods must become his friends."[28] Eitel was so taken with trees that he photographed them almost exclusively (fig. 10). Photographers gained from repeatedly visiting the same sites, deepening their knowledge of their subjects as well as the best weather and lighting conditions under which to photograph them.

Adhering to Emerson's adage that exotic subjects were unnecessary, American naturalists were content to work close to home. Instead of traveling long distances in search of the unusual, they happily essayed the everyday and ordinary. Eickemeyer was particularly adamant on this point, reveling in what he once called the "homely and commonplace." In 1898 he claimed that he had settled down to conquer the landscape and rural life available to him within a mere two square miles around his village of Yonkers, New York. "I have no sympathy with those who constantly run from one end of the country to the other in search of new and startling subjects My camera and I have pastured on a few old farms every Sunday for five years rain or shine in all seasons, and we find so much to occupy us that we have grown to look upon this territory as inexhaustible."[29] Among the photographs he made there was the award-winning *Sweet Home* (fig. 11). This image highlights Eickemeyer's interest in trekking through the wild, where, ideally, man made only temporary marks upon the land, such as a snowy footpath.

Creative American photographers at the turn of the twentieth century frequently took treks, hikes, and outings into nature. They went alone, with fellow photographers, and sometimes with family members but always with their cameras and the desire to be spiritually renewed by the experience. Camera clubs sponsored outings, the photographic press encouraged them, and new forms of transportation facilitated them.

Camera clubs in every part of the country organized outings for their members to promote both social interaction and the taking of naturalistic photographs. The Society of Amateur Photographers of New York and the Photographic Section of the American Institute, for instance, teamed up in 1887 to take a boat to Glen Island to photograph. Other New England groups ventured out to Long Island, up the Hudson River, and to the picturesque environs of villages like Gloucester, Massachusetts. In the Midwest, the Toledo Camera Club went on excursions and the Chicago Camera Club headed out

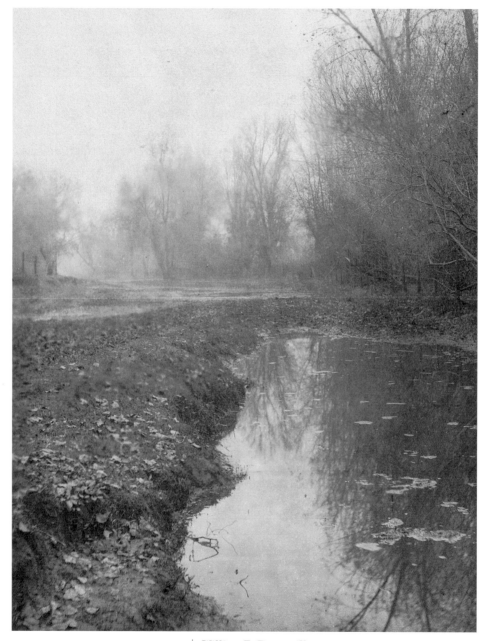

9. | William E. Dassonville
Untitled
c. 1910, platinum print, Minneapolis Institute of Arts, McClurg Photography Purchase Fund

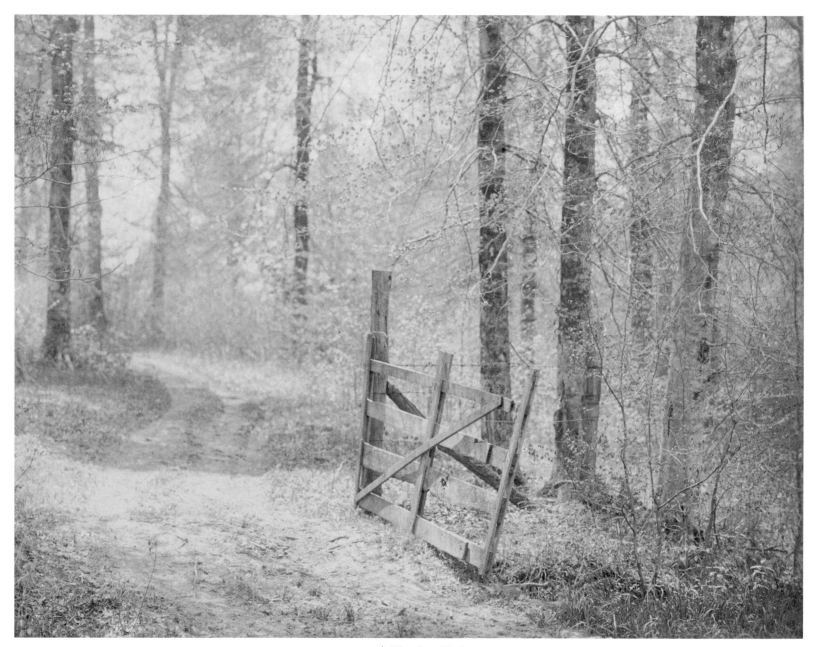

10. | **Theodore Eitel**
Untitled
c. 1910, platinum print, collection of the Theodore Eitel Family

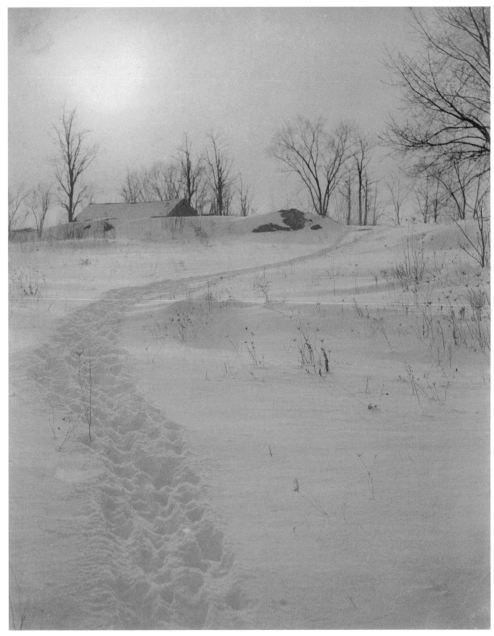

II. | Rudolf Eickemeyer, Jr.
Sweet Home
1894, platinum print, private collection

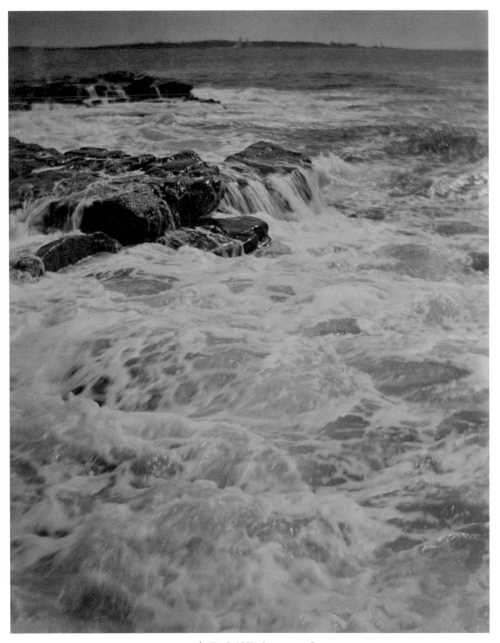

12. | Rudolf Eickemeyer, Jr.
Untitled

c. 1900, platinum print, private collection

to suburban creeks and fields. On the West Coast, the California Camera Club, based in San Francisco, was one of the country's most active groups of photographers that took outings. In the 1890s they often ventured into the wild once a month, sometimes for as long as ten days, when they trekked with their camping and photographic equipment to Yosemite Valley.

Photography magazines reported on these trips, recommended certain destinations, and urged their readers to get out into the open to shoot. In 1891 the *Photographic Times*, curiously, felt that so much of the United States had already been photographed that naturalists should head to the remote lake regions of northern Canada to encounter new terrain. About the same time, *American Amateur Photographer* ran articles about the photographic possibilities of the Adirondack Mountains and such foreign countries as Cuba, England, and Norway. The same periodical repeatedly recommended that its readers subscribe to the magazine *Outing*, for its excellent coverage of nature and adventures into it. Aware of photographers' interest in traveling, many railroads ran advertisements in the photographic press. The Missouri Pacific Railway, as an example, bought a quarter-page in a 1901 issue of *Camera Notes* to hype its service from New York to seven southern and western states. Magazines promoted outings as late as 1920, when *Camera* published an article titled simply "Rambling." The author began, "One of the greatest pleasures that can be enjoyed is to be found in rambling. Put on an old suit of clothes, sometime, so that you may push through brush and brambles, if you desire, without thought for your garments. Take a simple lunch and a camera, and set out without any particular objective in view or limit to your time, and put my assertion to the test."[30]

Eickemeyer did just that for years, making naturalistic photographs that frequently illustrated magazine articles by the art critic Sadakichi Hartmann. The two collaborated on at least nine articles, most of which appeared in such popular monthlies as *Harper's* and *Scribner's*. Hartmann used the "ramble" genre, established earlier by naturalist author John Burroughs,

to write in the first person about brief excursions he made to places like ponds, country lanes, and salt meadows. Rather than detailing the particulars of a site, he always addressed his personal feelings and sense of oneness with nature. In 1904 Hartmann wrote that a seashore walk had imparted to him "those subtlest of elementary emotions, which only the display of primitive nature can awaken in our soul."[31] For his part, Eickemeyer provided images that were, likewise, both generic and emotionally strong. His sensitive photographs did not document a specific place in nature but, rather, a typical scene artistically rendered. In one image, the swell of the foamy water and the solidity of the dark rocks spoke to the interaction of maritime and geological elements (fig. 12).

Around the turn of the twentieth century the new automobile and expanding rail lines made it possible for individuals to travel much greater

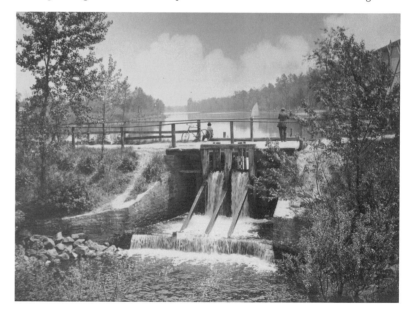

13. | **James Bartlett Rich**
Untitled
c. 1900, gelatin silver print, Minneapolis Institute of Arts, McClurg Photography Purchase Fund

distances than before. Most naturalistic photographers, however, preferred to stay close to home and find their subjects either on foot or by bicycle. Bicycles, in fact, became very popular with photographers at this time, both for their mobility and their ability to lug equipment. Companies manufactured carriers, mounts, and other products to encourage bicyclists to take along their cameras and to get photographers to ride their bikes out into the country. This worked to such an extent that bicycle and camera clubs sometimes merged their memberships, such as in San Francisco and Washington, D.C. The *Photographic Times* was particularly supportive of the camera-and-cycle movement, running articles on routes that were conducive to picture making and sponsoring a competition in 1899 for the best set of pictures made on a bike trip. Among the naturalistic photographers who heavily used bicycles was J. H. Field, who explored the environs of Fayetteville, Arkansas, with his. Even more devoted to this mode of transportation for finding his subjects was James Bartlett Rich of Philadelphia. Rich, in fact, imported and sold bicycles before becoming a professional photographer in 1901. He frequently pedaled to an isolated location to make his naturalistic photographs and even included his bike in some of his images (fig. 13).

Photographically Illustrated Nature Books

Coincident with the revolution in transportation came new developments in printing, which naturalistic photographers likewise embraced. In the 1890s publishers began illustrating more of their books and magazines with photographic reproductions rather than hand-rendered images. The new halftone process allowed them to more economically print photographic images, which the general public craved. So many of these illustrations were of landscape and other rural subjects that in 1905 an editorial in *Photo Era* noted a virtual "flood" of books and periodicals on nature and outdoor life.

Eickemeyer's work was prominent in the book trade at this time. Between 1900 and 1903 the high-end publisher R. H. Russell issued three oversized books illustrated with his naturalistic photographs. The first was *Down South*, featuring his sympathetic images of southern blacks eking out their rural lives on land they did not own. Despite their subservient roles, Eickemeyer's subjects are infused with a sense of dignity and determination. For the book's cover he chose the image *Who's Dat?* depicting an encounter among strangers of different generations (fig. 14).

Next came *The Old Farm*, with various pictures of animals, barns, fields, and farmers. Each image was accompanied by short extracts by American poets such as Henry Wadsworth Longfellow and Ralph Waldo Emerson. Eickemeyer chose related pictures of a horse-drawn carriage as the first and last reproductions, suggesting a rural outing and giving the book a pleasant narrative. He believed his visual essay would strike a chord with many of his readers and wrote in the introduction, "There are few of us who have not in our moments of leisure dreamed of some ideal spot to which we might some day retire, there to live out the remainder of our days in peacefulness and quiet contemplation. This Utopian dream in many instances has for its center of activity, or rather inactivity, a farm." [32]

In 1903 Russell published Eickemeyer's *Winter*, with an introduction by Hartmann. Rather than address Eickemeyer's specific pictures, Hartmann once again essayed his general feelings about the subject. He stated that he found beauty in every season and that winter was both his favorite and "the most intellectual of all the seasons; that is, it is the time of the fullest and freest flow of thought and bright ideas." [33] Eickemeyer was undoubtedly invigorated by winter, given the quantity of photographs he made at this time of year. While most photographers concentrated on darkroom work during the cold months, he continually ventured out with his camera, making winter one of his best-known subjects. Eickemeyer's images in the book show ice and snow covering all kinds of landscapes and in all kinds of light. Among them was his early classic *Sweet Home* (fig. 11), with its elevated horizon line.

Henry Troth, of Philadelphia, also provided illustrations for

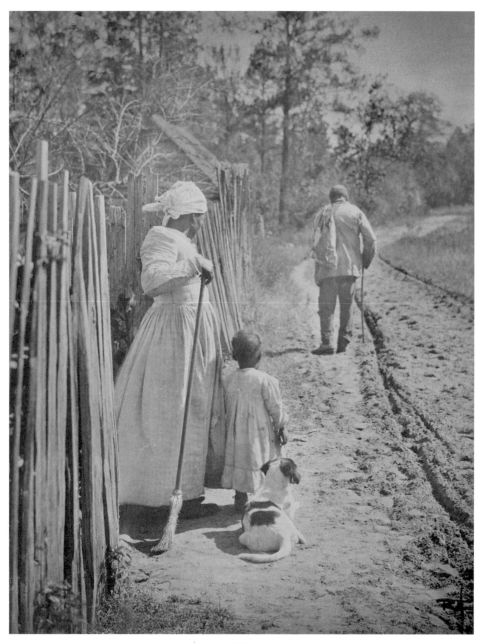

14. | Rudolf Eickemeyer, Jr.
Who's Dat?
1894, platinum print, J. Paul Getty Museum

many nature books. As a professional photographer he specialized in straightforward flower pictures that were used in numerous botanical and natural-science publications. His personal, naturalistic pictures, however, appeared in books that dealt with the more spiritual side of nature. In 1902 Troth illustrated *A Journey to Nature*, J. P. Mowbray's tale of a young stock broker who spent a year in a "weather-beaten hut" far from Wall Street after experiencing health problems attributed to the stress of his job. Troth provided soothing images of the recuperative setting the lad inhabited, with its fields, streams, woods, and dirt roads.

Troth's naturalistic images appeared in two additional back-to-nature volumes. In 1911 he supplied more than a dozen illustrations for *A Window in Arcady: A Quiet Countryside Chronicle*, by Charles Francis Saunders. This book comprised the author's observations of nature, month by month, in areas that Troth knew well. The chapter on May, for instance, included a halftone of his photograph *In Springtime, Pennsylvania* (fig. 15). This image reveals Troth's power of observation and skill at composing with simple elements. A 1912 edition of Sidney Lanier's *Hymns of the Marshes* also featured Troth's work. The text is made up of Lanier's long poems on sunrise, sunset, individuality, and the marshes of Glynn. For this book Troth photographed near Brunswick, Georgia, the site of Lanier's inspiration, producing contemplative renditions of the area's water, weeds, and trees.

Other naturalistic photographers who undertook book illustration included J. H. Field and Frances and Mary Allen. Field supplied images for William R. Lighton's *Happy Hollow Farm* (1915), a fictional account of a couple who bought a run-down farm in rural Arkansas and renewed themselves by making it self-sufficient. The Allen sisters, like Eickemeyer and Troth, illustrated many nature books, the most significant of which was *A White Paper Garden* (1910), by Sara Andrew Shafer. Shafer penned monthly advice on gardening, while the Allens pictured landscapes at the appropriate time of year. Their evocative images included some color ones, like the frontispiece depicting a mother and her children enjoying summer grasses and flowers.

Rural and Domestic Subject Matter

It is clear from these examples that American naturalistic photographers essayed a wide variety of rural and domestic subjects. Many of them began at home, photographing their own simple lives, which, invariably, became their most intimate and familiar topic. Daily chores like washing and cleaning evoked both pride in hand labor and a sense of self-sufficiency. Sarah J. Eddy sometimes pictured the clean and airy environments that housewives enjoyed during their day. The woman in her *Sunny Kitchen* (fig. 16), for instance, seems completely content with her task and her well-lit workstation. Similarly, Harry G. Phister produced images extolling the virtues of a vernacular lifestyle. Among his favorite spots to set up his camera was a local well, where villagers not only gathered water but took in the fresh air and conversed with one another (fig. 17).

Flowers and gardens were also fertile material for these individuals. The blooms of nature easily beckoned the naturalist photographers, drawing them out into their yards and deep into the forests. William B. Post, of Maine, regularly photographed the flowers of his wife's lush garden at the height of his state's abbreviated growing season. Rather than merely isolating individual specimens, however, he sometimes encompassed whole swaths of this environment to make pictures that played with visual space, simultaneously suggesting both great depth and flatness (fig. 18). As previously indicated, Henry Troth continually trained his camera on flowers. In 1897 he wrote a series of articles on amateur photography for *Ladies' Home Journal*, one of which was on photographing wildflowers. Crammed into this one-page essay were no less than ten reproductions of Troth's own images and the assertion "It is true of wild flowers, as of other living things, that photographs of them are of the most universal interest when taken in their native haunts; that is where we go to find them, and it is where we think of

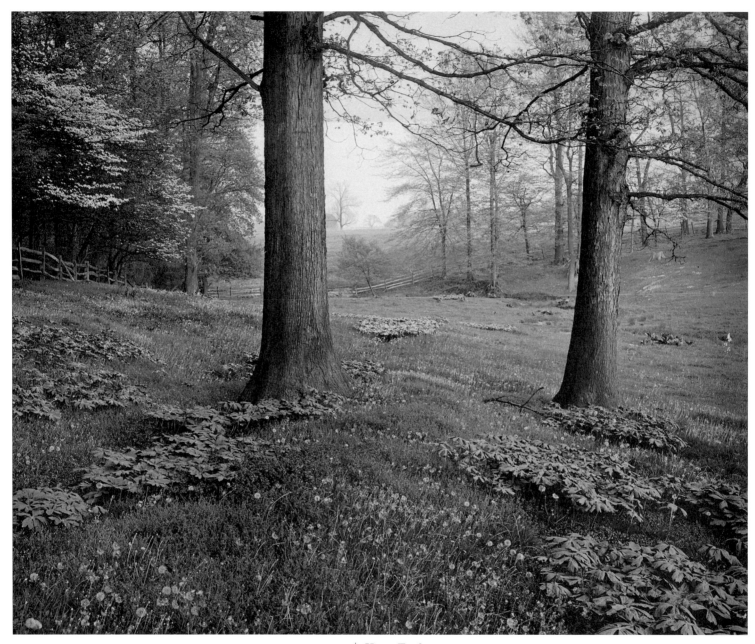

15. | Henry Troth
In Springtime, Pennsylvania
c. 1900, platinum print, Minneapolis Institute of Arts, McClurg Photography Purchase Fund

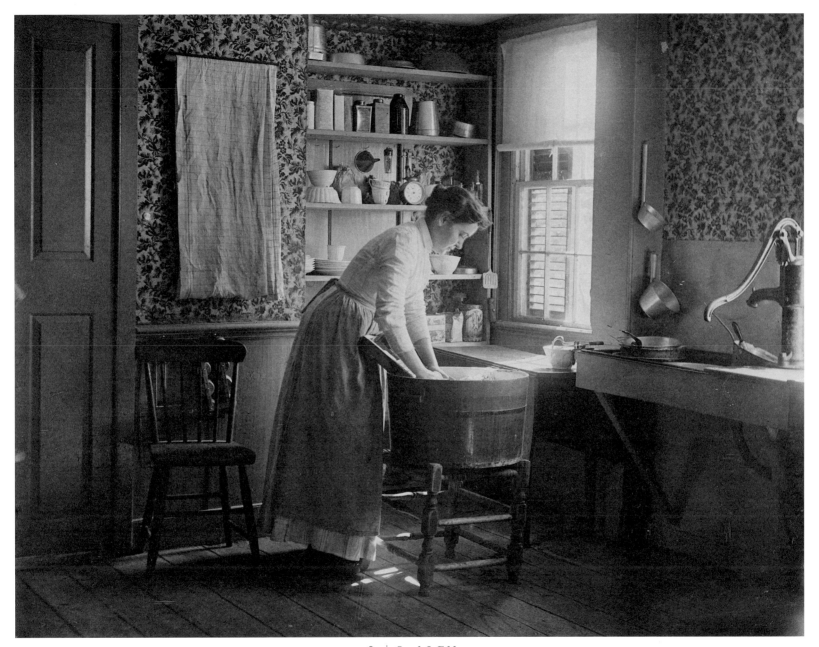

16. | Sarah J. Eddy
Sunny Kitchen
c. 1900, platinum print, Minneapolis Institute of Arts, McClurg Photography Purchase Fund

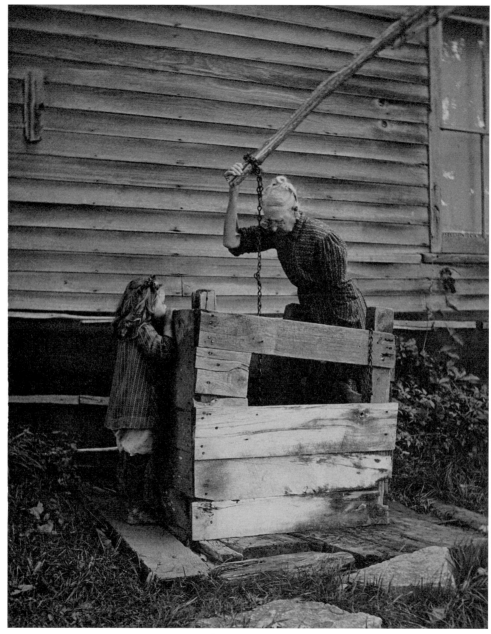

17. | Harry G. Phister
Untitled

c. 1900, platinum print, Minneapolis Institute of Arts, McClurg Photography Purchase Fund

18. | **William B. Post**
Entrance to Mary's Garden
c. 1900, platinum print, Minneapolis Institute of Arts, McClurg Photography Purchase Fund

them."[34] Equally committed to flowers was the Massachusetts photographer Edwin Hale Lincoln. Lincoln was a devoted naturalist as well as naturalistic photographer, going to great lengths to preserve his subjects (fig. 19). He railed against those who took plants from the wild, especially orchids, which he viewed as victims of their own beauty. Lincoln would often carefully dig up his specimens, take them to his home studio to photograph, and then return them unharmed to their original site, which he never revealed to others. He published editions of original platinum prints, all of which were meticulously documented and beautifully rendered. He issued his last set in 1931, *Orchids of the North Eastern United States*. Like his earlier photographs, these were of individual flowers in understated arrangements against a flat neutral background (fig. 20).

Trees naturally crept into the pictures of many photographers working in the open, but Theodore Eitel concentrated on them almost exclusively. Eitel reigned as the leading photographer of trees from 1905 to about 1925, the period when the *American Annual of Photography* reproduced one of his images every single year, an almost unequaled achievement. In 1910 he wrote a lead article for *Photo Era* in which he noted the importance of trees to artists in other media and recommended their close study. "The trees, which have inspired so many poets, musicians, and painters, have served as the principal pictorial material for the student of photography, more particularly him who has intimately communed with these stately evidences of nature's handicraft."[35] He then went on to assert that particular trees often evoked specific emotions in humans, such as fir suggesting desolation. Eitel's images almost always entailed a careful asymmetrical composition anchored by a single tree trunk in the foreground (fig. 21).

While most naturalistic photographers stuck literally to terra firma, those who lived on the Atlantic or Pacific coasts found additional possibilities in the water that stretched out before their inquisitive eyes. Photographic periodicals regularly ran articles encouraging their readers to make marine studies of waves, bays, boats, and coves as well as the surf and seashore (fig. 22). On the Massachusetts peninsula, Martha Hale Harvey was particularly drawn to the picturesque coastal village of Annisquam, just north of Gloucester. There she sensitively depicted the subtle way in which the land, sea, and sky played off of one another (fig. 23). Harvey made large platinum prints, fitting for the expansiveness of her sublime subjects. In California, Willard E. Worden excelled at combining part of the Pacific Ocean with significant land formations in his images (fig. 24). Consequently, he was able to play with such key elements of "landscape" photography as unity, breadth, balance, and subordination.

Photographers who worked outdoors were keenly aware of both the weather and the seasons. They usually avoided working on clear or overcast days, preferring the character and definition that clouds gave their images. As early as 1893 it was observed that "there are few landscape pictures that are not considerably improved by good cloud effects."[36] William J. Mullins made clouds the very subject of one of his photographs, rendering the earth below them in total darkness (fig. 25). Though it is unlikely that Mullins used combination printing in this picture, most naturalistic photographers were not adverse to printing in cloud effects from secondary negatives—the only kind of manipulation sanctioned by P. H. Emerson himself.

The seasons and the months of the years were just as ethereal and inviting a subject as was the weather for many American naturalistic photographers. Eickemeyer and Post were both known for their photographs of snow but, in fact, were each as interested in winter as a season as snow a subject. Eickemeyer, after all, published an entire book titled *Winter*. Photographers, understandably, usually represented the seasons by their most characteristic aspect: the snow of winter, the apple blossoms of spring, the outdoor activities of summer, and the harvested fields of fall. Photographic magazines ran editorials about the qualities of the outdoors during the month of publication and then extolled their photographic possibilities. Photographers regularly titled their pictures after the month they depicted

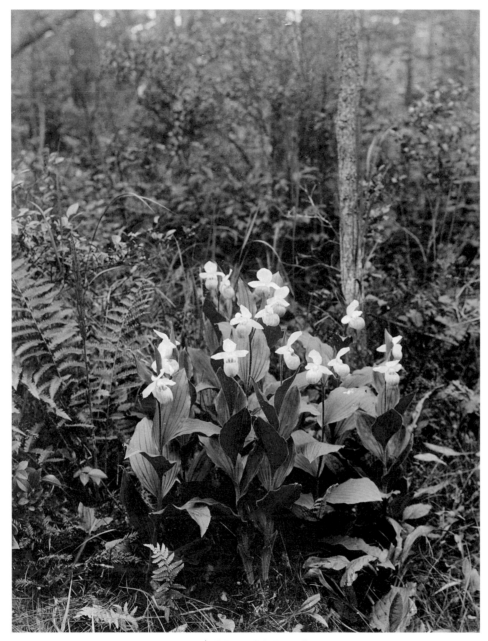

19. | **Edwin Hale Lincoln**
"Cypipedium Reginae" in Swamp: An Orchid in Habitat
1931, platinum print, Minneapolis Institute of Arts, gift of Richard and Susan Nunley

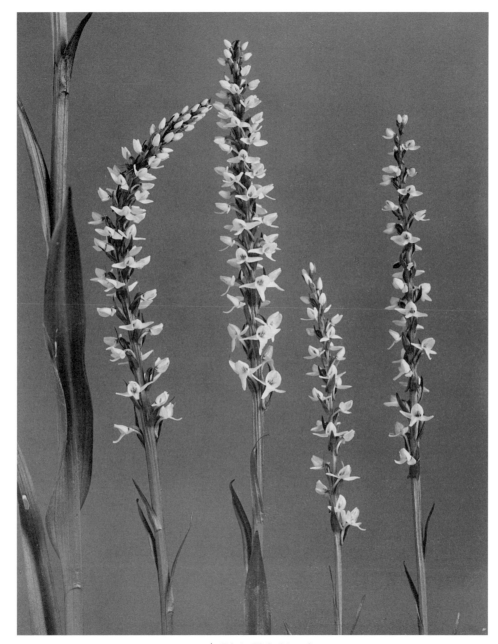

20. | **Edwin Hale Lincoln**
"Habenaria Dilitata": Tall White Bog Orchid
1931, platinum print, Minneapolis Institute of Arts, gift of Richard and Susan Nunley

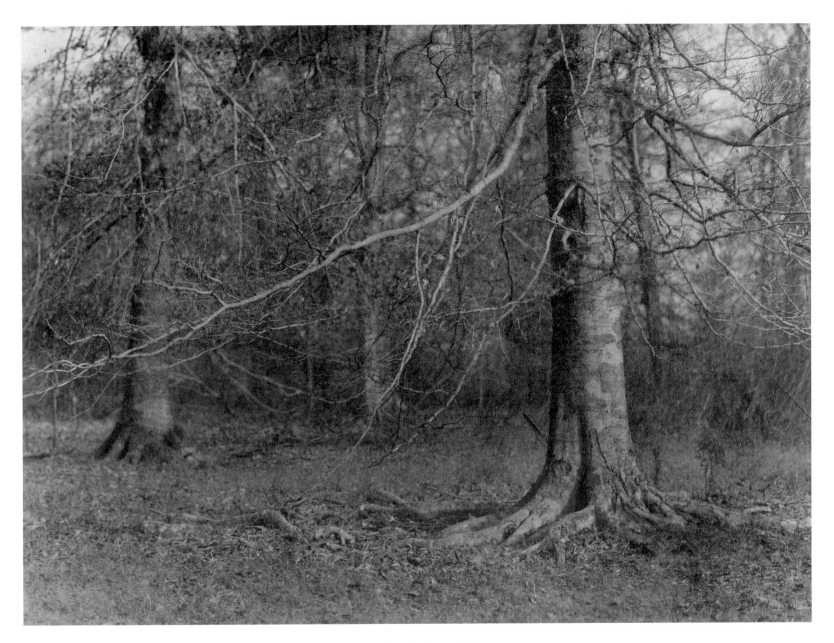

21. | **Theodore Eitel**
Untitled
c. 1915, gelatin silver print, collection of the Theodore Eitel Family

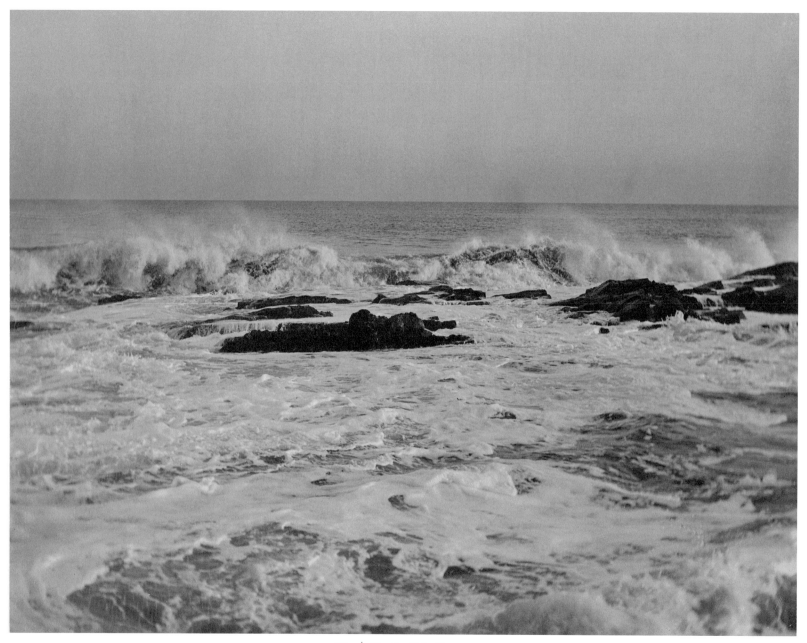

22. | **Martha Hale Harvey**
Breaking Waves
c. 1900, platinum print, Minneapolis Institute of Arts, McClurg Photography Purchase Fund

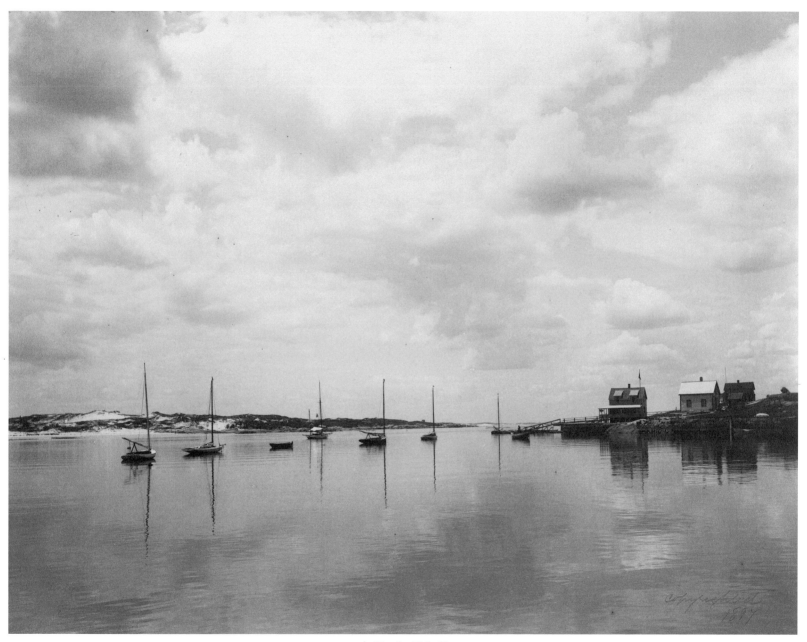

23. | **Martha Hale Harvey**
Annisquam, Massachusetts
1897, platinum print, Minneapolis Institute of Arts, McClurg Photography Purchase Fund

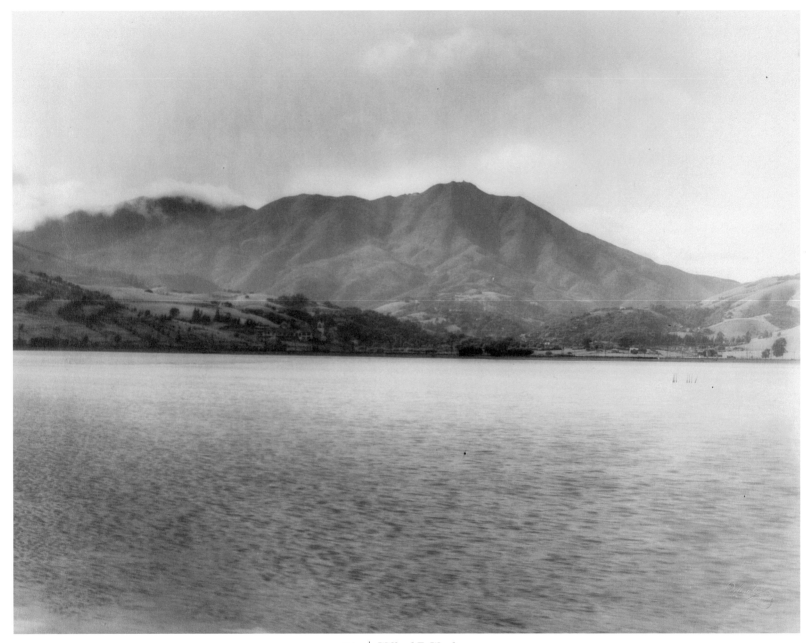

24. | Willard E. Worden
Mount Tamalpais, Marin County, California

c. 1915, gelatin silver print, Minneapolis Institute of Arts, McClurg Photography Purchase Fund

and, as previously noted, illustrated whole books with texts that ran from January to December.

Some naturalistic photographers concentrated on pure landscapes, preferring that their images be uninhabited. Others, however, skillfully incorporated human figures into their compositions, signaling their belief in the oneness of man and nature. Different impressions were imparted, depending upon the scale and placement of the figures. Small and distant ones suggested the respectful awe that humankind had for its natural surroundings. Large and dominant figures emphasized the strong character of generic types who lived off the land. In 1900 a writer for *Wilson's Photographic Magazine* declared, "Figure work out of doors, in natural attitudes and amid natural surroundings,

is one of the most alluring of photographic specialties."[37] Photographers succeeded best when they pictured figures doing something, rather than posing, and not looking at the camera, a stance typical of portraiture. P. H. Emerson, in fact, made primarily figure-in-landscape compositions. And Alfred Stieglitz, among others, also worked in this naturalistic genre, creating images such as *Weary* (fig. 6) and *Mending Nets* (fig. 7). Stieglitz's accomplishments were admired by many critics, including one who observed, "There is an absolute unconsciousness on the part of the subjects or models, of the existence of the camera, and this is perhaps the true secret of obtaining successful pictures of landscapes with figures."[38]

American naturalistic photographers found many of their figure-in-landscape subjects on farms. They reveled in the variety of outdoor activities that farmers undertook to make a living and maintain their property. Robert S. Redfield frequently photographed the daily goings-on of farms in rural Pennsylvania. He often included children in his images, learning from their parents and suggesting the continuum of farming generations. Youngsters alone were also pictured in rural leisure-time activities like playing with chickens and blowing bubbles (fig. 26). And adults alone were portrayed plowing, tending livestock, and performing other grown-up chores (fig. 27).

Haying was perhaps the most favored farm activity. Naturalistic photographers latched onto this subject because they considered it more symbolic of man's dependence upon Mother Earth than images of, say, haystacks alone. Pictures of haying were rampant in the photographic press and often prize winners at competitions. T. O'Conor Sloane, Jr.'s harvest image, for instance, depicts a solitary farmer working with his pitchfork under the kind of threatening autumn sky typical for the time of year (fig. 28). More characteristic of haying images, however, is Louis F. Stephany's *The Last Load* (fig. 29), which shows a number of workers in the field. Haying was almost invariably a group effort, due to the need to harvest quickly. Family members

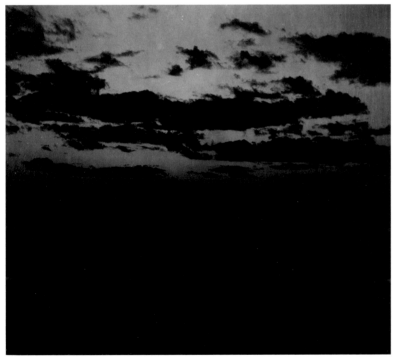

25. | William J. Mullins
Untitled

c. 1900, platinum print, Minneapolis Institute of Arts, McClurg Photography Purchase Fund

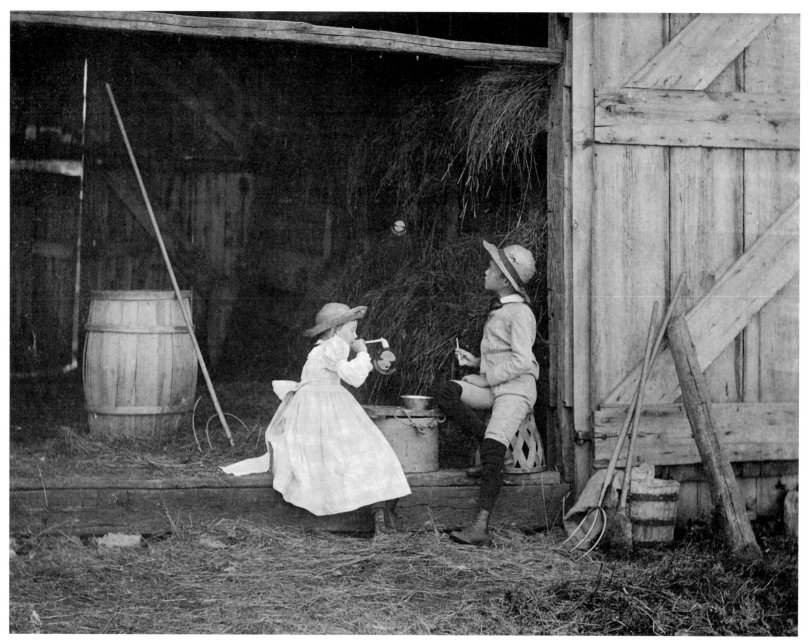

26. | **Robert S. Redfield**
Bubbles

c. 1890, platinum print, Princeton University Art Museum, gift of Donald R. Griffin

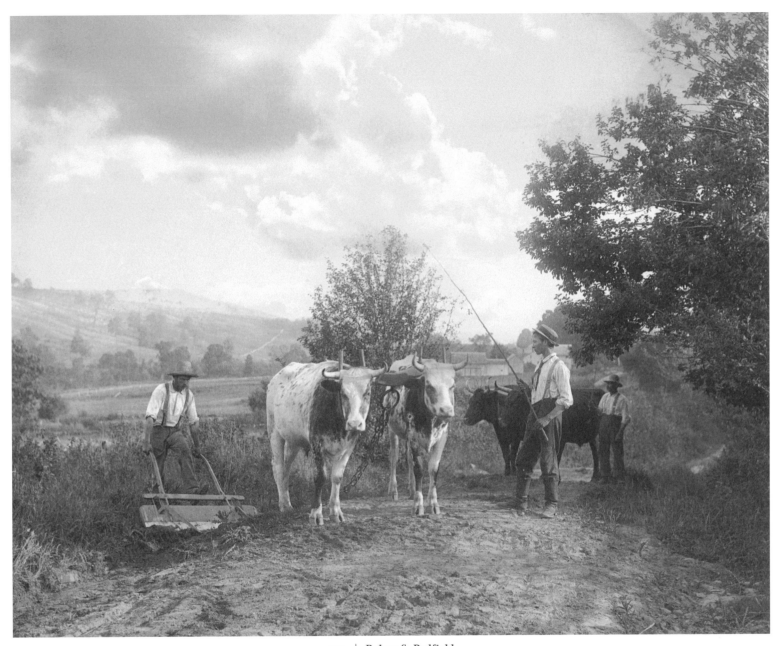

27. | **Robert S. Redfield**
Untitled
c. 1890, platinum print, J. Paul Getty Museum

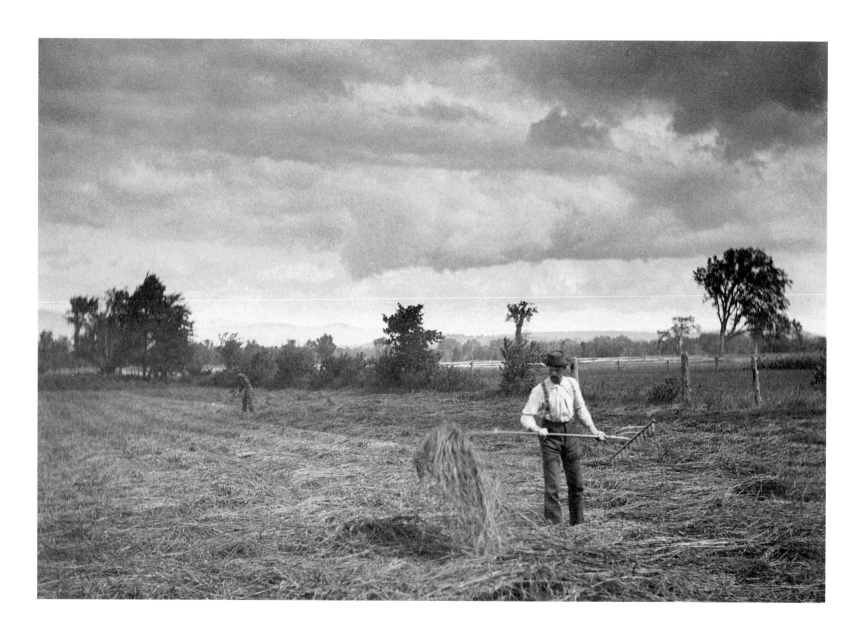

28. | T. O'Conor Sloane, Jr.
Untitled

c. 1900, platinum print, Minneapolis Institute of Arts, McClurg Photography Purchase Fund

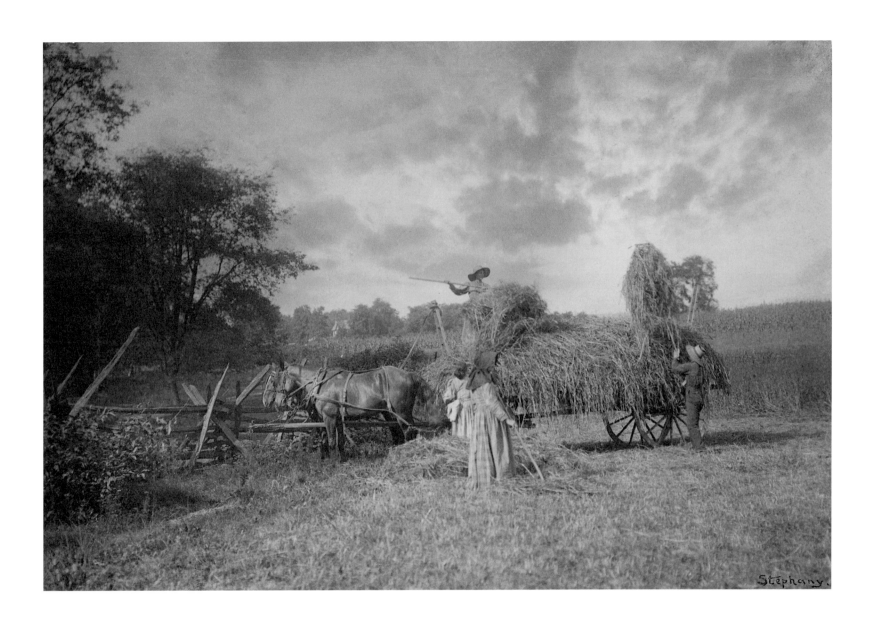

29. | Louis F. Stephany
The Last Load
c. 1900, platinum print, Minneapolis Institute of Arts, McClurg Photography Purchase Fund

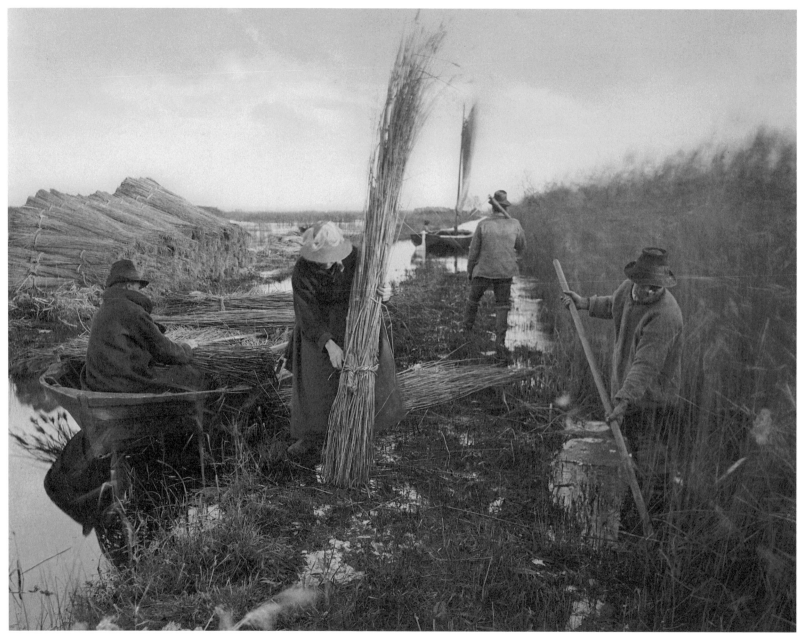

30. | **Peter Henry Emerson**
During the Reed Harvest

1886, platinum print, Minneapolis Institute of Arts, McClurg Photography Purchase Fund

and fellow farmers joined together in a communal effort that both accomplished the mission and formed strong interpersonal bonds. Images of this activity incorporated not only the workers and the hay but the pitchforks, wagons, animal teams, and other equipment vital to a successful harvest. P. H. Emerson provided fitting precedents for these haying images in the many photographs of reed harvesting that he produced in the 1880s. In them he shows his simple English folk cutting, poling, towing, and ricking the marsh reed and hays of the Norfolk Broads (fig. 30).

Emerson's *Gathering Water Lilies* (fig. 1) became a talisman for American naturalistic photographers, and replicating it became something of a rite of passage for them. Eickemeyer and Post each made at least two pictures directly inspired by this image in the 1890s. Eickemeyer's, like Emerson's, included a man rowing in the front of the boat and a well-dressed woman plucking a flower from the rear (fig. 31). One of them illustrated an article by Sadakichi Hartmann titled "The Pond," in which the author observed of the water lily, "She is the popular favorite, the queen of our inland waters. Her large, handsome leaves make us think of glassy lakes with green banks and a leisure hour perhaps spent in a rowboat with a friend."[39] Emerson himself wrote two and a half pages on water lilies in *Life and Landscape*, covering, like a horticulturist, their habitat, colors, smell, folklore, and other characteristics. Post's image, *Summer Days*, pictured a woman alone, in a sun-drenched and tranquil scene that, like Emerson's, was shot from an elevated vantage point (fig. 32). Post, unlike others, created a more contained composition by excluding the horizon line in his image. Nevertheless, he still incorporated a subtle sense of depth, by softly rendering the foreground and background, purposely invoking Emerson's concept of differential focusing.

Differential Focusing in American Naturalistic Photography

In the United States differential focusing was addressed extensively in the photographic press and was prevalent in photographers' work. As early as 1891 the *American Annual of Photography* made the distinction, like Emerson, between pictures with no definition whatsoever and accomplished naturalistic images. Writing for the annual, J. Traill Taylor stated, "Let not 'fuzzytypes' be confounded with the effect aimed at by the naturalistic school. The two things are different. In the former everything is blurred; in the latter the sharpness is confined to the dominant object in respect of definition. This has long been recommended and practiced by our best photographers, and it accords with common sense and artistic taste of the most common character."[40] "Fuzzytypes" and other prints that were completely out of focus were criticized for going to extremes and destroying the structure of the image. Photographs that featured selective focus, on the other hand, were applauded for appropriately subordinating minor aspects of the image and for approximating normal human vision.

Magazines continued to run articles on focusing for years. In 1908 *Camera* pointed out that there was nothing more false to nature than images of

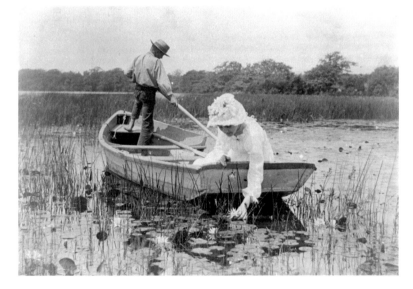

31. | Rudolf Eickemeyer, Jr.
The Lily Gatherer
1892, platinum print, Library of Congress

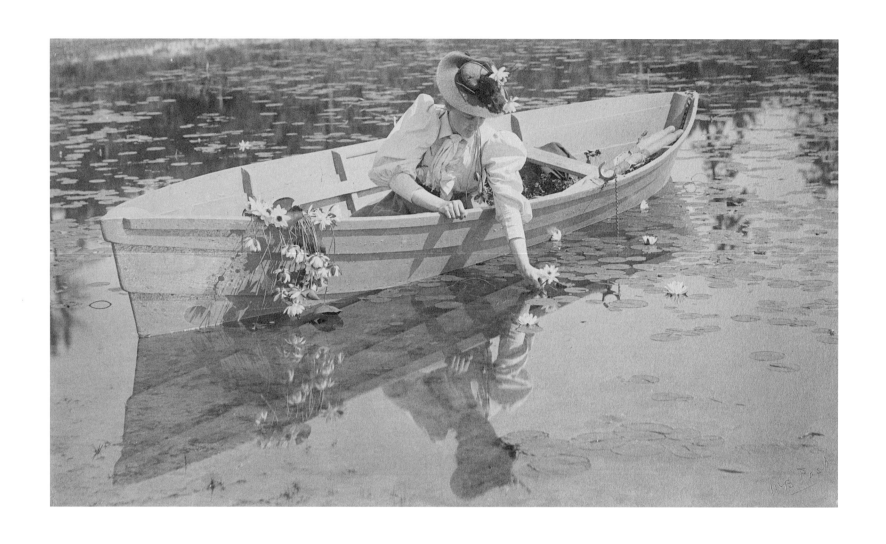

32. | William B. Post
Summer Days
c. 1895, platinum print, Minneapolis Institute of Arts, McClurg Photography Purchase Fund

minute, overall sharpness: "The use of a very small stop [lens aperture] has the evil effect of destroying any sense of atmosphere. Moreover, it ruins the modeling, with the result that we get neither true perspective nor value, and everything is as an unnaturally flat plane."[41] Ten years later the same magazine was still interested in "The Focus Question," the title of an article in which the writer asserted, "What part of your picture is the most important is for the artist himself to determine. It may be in the immediate foreground, if so, there should be the greater sharpness, but if the interest is elsewhere, then let that part make its existence recognizable."[42] Curiously, another author attributed male and female qualities to the soft and sharp areas of a successful landscape photograph. "Often the objects of the material of the background are best when only suggested," wrote F. A. Waugh in 1901. "The delicacy with which these impressions are given is often the chief grace of a good picture. It is the femininity of picture-making. The foreground is masculine. A man always plants himself in the foreground and proposes in blundersome, rugged words; but usually not until the woman from the background has offered herself in a hundred gentle flickering suggestions."[43]

American naturalistic photographers utilized differential focusing most effectively when there was a fair amount of distance in their landscapes. A defined foreground, middle distance, and background made it easier for them to render one area in bolder relief. Not surprisingly, they often presented their primary subjects in the middle ground. This invariably yielded a gentle visual transition up to the subject and an atmospheric screen behind it. Such is the case in Post's quiet image of a wooden post at the edge of a stream (fig. 33). Rocks and moving water in the foreground are easily recognizable but somewhat muted. The post, the only vertical and man-made element in the picture, is crisply rendered and clearly the thing that drew the photographer's attention. And the background is a scrim of gray values, representing grasses and trees.

Some subjects, however, did not lend themselves to an equal balance between all planes in the resulting image. Forests, for instance, because of their density, usually offered the photographer a condensed space, with the background filling up quickly with tree trunks. Theodore Eitel, the photographer of trees, was well aware of this and usually focused on an area closer to the camera. About pictures of the interiors of woods, he declared, "Some good examples may be seen where the operator, with the use of an excellent [lens], ... has chosen his focus in the near foreground, middle distance and background softly diffused, not blurred."[44] Eitel usually focused on a tree only feet away from his camera, while the rest of the forest stretched on for a great distance in his images.

Frances and Mary Allen often used differential focusing to help draw attention to particular objects or spots in their compositions. They adeptly played soft and sharp areas of a picture off one another, such as in *Constance* (fig. 34). Here, the potted flower is crisply rendered against a backdrop of leaves that is uniformly out of focus. The figure's gesture and gaze also assist in directing the viewer's attention to this tiny part of the image. The Allen sisters shared Emerson's belief in making photographs that were focused in such a way as to mimic human vision. After winning a competition with one of their pictures, they declared, "The eye cannot focus itself on every object in its field of vision at the same time. If a photograph does this, the effect is hard and unnatural."[45] The effect they desired was, by contrast, delicate and natural.

Most photographers interested in such effects used regular equipment to obtain them. They easily achieved differential focusing by opening up the aperture of their lenses to create a shallow depth of field. A few, however, opted for special lenses that induced spherical aberration, an optical effect that rendered the center of the image sharp and the edges soft. Doris Ulmann, for instance, used such a lens for her large body of figure work. Whether she was photographing professionals in the Northeast or the poor of the South (fig. 35), Ulmann chose to render her subjects in a careful combination of soft and sharp focus. Notably, the center of her attention was usually her sitter's

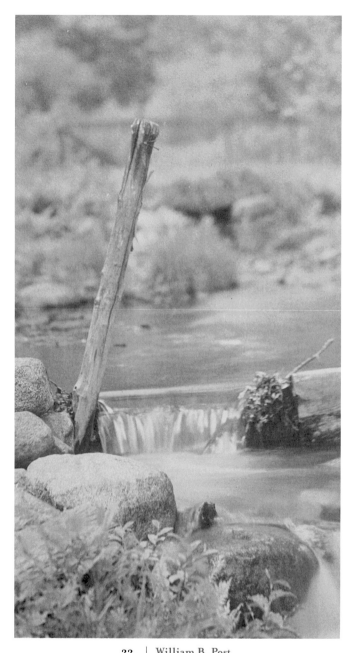

33. | **William B. Post**
Untitled

c. 1900, platinum print, Minneapolis Institute of Arts, McClurg Photography Purchase Fund

34. | **Frances and Mary Allen**
Constance
1897, platinum print, Philadelphia Museum of Art, gift of William Innes Homer

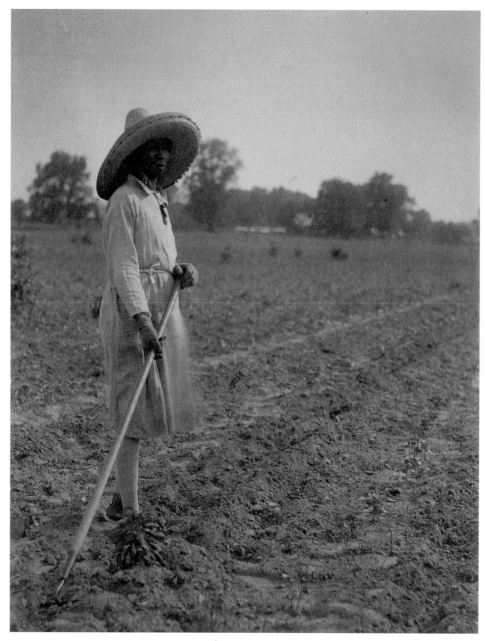

35. │ Doris Ulmann
Farm Worker
c. 1925, platinum print, collection of Dan Shogren

hands rather than face, as in normal portraiture. This reinforced the idea that the individuals pictured used their hands for their work. Surgeons, editors, and farmers alike were shown to be part of the vast array of American labor, utilizing (albeit in different ratios) hand, heart, and head in their daily tasks.

Compositional Simplicity in American Naturalistic Photography

American naturalistic photographers adhered to Emerson's insistence on simple compositions, just as they did to his theory of differential focusing. They learned to turn their cameras on a single subject rather than a horde of objects. They practiced the power of selection, eliminating anything that was extraneous, excessive, and unnecessary. While topographical photographers strove to include as much as possible in their frames, naturalists worked to eliminate as much as possible. The author of an 1898 article titled "Naturalness in Photography" stated that photographers should "aim at simplicity. See what you can leave out of a picture, rather than what can be packed into it. Simplicity is the chief attribute of all art."[46]

Naturalistic photographers consistently worked in this manner, avoiding all-inclusive landscapes. Eickemeyer and Post, for instance, often made nearly abstract photographs by focusing on a small portion of a scene rather than the entire bounty of Mother Nature before their eyes. Eickemeyer declared that "more picturesque results can be attained by the successful interpretation of simple subjects near at hand than in photographing of mountain ranges, huge cataracts, or other stupendous phenomena of nature."[47] Alfred Stieglitz had no problem selecting solitary figures for his images, presenting them as symbols of entire classes of rural folk (figs. 6 and 7). John G. Bullock, likewise, demonstrated his skill at making photographs of extreme simplicity and understatement. One captures the modest act of a girl feeding a donkey in a sun-drenched setting (fig. 36). Here, Bullock centered the child and the animal and framed them in a manner that eliminated most of their surroundings. Only the uniform foreground of grass

and background of shrubbery remain, creating a well-measured composition of two horizontal bands.

The simplicity of American naturalistic photographs was reflected in the straightforward manner in which they were produced. Their makers eschewed overt handwork, manipulation of the image, and other methods of photographic "faking." While pictorial photographers flamboyantly altered their work in the darkroom, naturalists revered the sanctity of their photographic negatives. In England, Emerson was willing to print in clouds from a second negative, but all other feats of darkroom magic were stringently avoided. In this country, some naturalistic photographers took an even more purist approach to their work. Harry G. Phister, for instance, urged his fellow photographers to capture everything they wanted in the final picture on a single negative. In one of many articles Phister wrote on landscape photography, he claimed that "it is not difficult to produce a negative which will show all of the beautiful cloud forms and one in which the landscape and sky will print out at the same time without any faking."[48] To him, the idea of piecing together an image from more than one source was deceptive, fraudulent, and downright unnatural.

Phister and American naturalistic photographers invariably chose to print their images in platinum, the type of paper preferred by most artistic photographers. Platinum was favored for its subtle range of middle tones and its deep, rich blacks. Albumen prints, which were the standard before about 1890, and gelatin silver prints, which dominated after about 1920, were noticeably harsher in their values and blander in their surface qualities. Platinum prints, by contrast, were easily more elegant, refined, and tasteful.

In 1887 the *Photographic Times* led off one of its issues with a poem about the waning use of albumen paper in favor of platinum. Over the next decade numerous photographic periodicals printed articles about platinum paper—preparing it, developing it, toning it, and about its beauty and permanency. Alfred Stieglitz, one of its leading users and advocates,

36. | **John G. Bullock**
Untitled
c. 1900, platinum print, Minneapolis Institute of Arts, McClurg Photography Purchase Fund

contributed at least five articles about platinum to the *American Amateur Photographer* in the early 1890s. At the same time, camera clubs like those in Boston and Stieglitz's own in New York saw platinum prints dominate their annual exhibitions of members' work. Years later landscape photographers especially continued to print their work in platinum. In 1909 one writer asserted, "Without doubt, the platinum printing-process is best suited to landscape photography, in tone, texture, and breadth of effect."[49] It was not until World War I, when the metal became extraordinarily expensive due to military uses, that platinum fell out of favor with most creative photographers.

Artistic Aspirations and Influences

Naturalistic photographers were artists at heart. Despite their straightforward printmaking methods, they wished to express personal emotions in their work rather than record the bare facts of nature. They strove to make creative images with their cameras, not mere snapshots or topographical pictures. The art critic Charles Caffin pointed out that admitting to the mechanical nature of photography did not preclude skilled individuals from using the medium for aesthetic purposes. And he was most taken with artistic photographs that pictured Mother Nature in all her charms. In his landmark book *Photography as a Fine Art: The Achievements and Possibilities of Photographic Art in America*, he wrote that "the lover of nature can never be satisfied with a mere record of the physical facts; to him there is, as it were, a soul within them, and he looks in pictures for its interpretation. It would not be far wrong to say that landscape art is the real religious art of the present age."[50]

Nature, of course, was the naturalist's primary subject, but nature on its own did not make art. Creative landscape photographs came about only if makers were able to successfully render their interpretation of the scene, through personal vision and sentiment. Their pictures were evidence of nature seen through the eyes of an artist. In an article published in the United States titled "Naturalism in Photography," the English photographer A. Horsley Hinton pointed out, "The joyousness, the grandeur, the sadness of the landscape have no actual existence; they are the personal contribution of a human temperament."[51]

It is not surprising that American naturalistic photographers looked to the other arts for inspiration. It also made sense that they were particularly drawn to some of the same European artists that Emerson admired, most notably the painters Corot and Millet. Their work was frequently reproduced in the photographic press in articles about composition, landscape photography, and other topics. Sadakichi Hartmann urged photographers to study their paintings, because they were often virtually monochromatic and because they utilized ordinary subject matter found close to home. One writer suggested to photographers that trees were an easy subject and noted Corot's use of them: "Corot, that famed French landscape painter, was a great lover of trees. They were to him as intimate friends, and he loved them, not for the cut of their clothes, but for the beauty of their souls."[52] Eickemeyer was explicit about Millet's work being the genesis for some of his own. He told Hartmann that his photographs of southern blacks (fig. 14) sprang from the example of Millet's paintings of French peasants. Eickemeyer admired the dignity and pride that Millet portrayed in his rural folk and wished to do the same with American counterparts.

Ethnographic Concerns

Although Eickemeyer cited artistic inspiration for his images of southern blacks, this work also reveals ethnographic concerns. Like Emerson, some American naturalistic photographers approached their human subjects with as keen an interest in their culture as their picturesque appearance. Eickemeyer's southern photographs, for instance, picture numerous aspects of the lifestyle of poor black farmers. He respectfully showed them plowing, planting, and harvesting the fields, preparing meals, gathering water, and

maintaining livestock. More than just props in a careful photographic composition, Eickemeyer's subjects represented a distinct regional heritage that the photographer wished to nurture.

Shortly after the turn of the twentieth century, many Americans increased their awareness of the traditional southern lifestyle and worked to preserve it. Among the naturalistic photographers who joined in this movement was Doris Ulmann of New York. Initially Ulmann photographed such New England cultures as the Mennonites and Shakers, but she soon directed her attention south, partly inspired by the anthropological work of Margaret Mead. There, she turned her camera on the inhabitants of the Appalachian Mountains and blacks of the Deep South, in order to help preserve ways of life that were fast vanishing. Significantly, she traveled with the folklorist John Jacob Niles, who only deepened her cultural understanding of her subjects (fig. 38).

In the 1930s two books illustrated with Ulmann's southern photographs appeared. The first, *Roll, Jordan, Roll*, featured primarily images she made on the South Carolina plantation of Julia Peterkin, the book's author. Ulmann's pictures sensitively depict the everyday life and religious rituals of the Gullah blacks, who were former slaves from Liberia. Jointly, Peterkin's text and Ulmann's images celebrated a unique and isolated Afro-American culture that persisted nowhere else. The second book, *Handicrafts of the Southern Highlands*, extensively documented the history, methodology, and makers of Appalachian handmade products. Numbering more than 350 pages and reproducing nearly 60 of Ulmann's images, the tome was meant to inspire the use of handicrafts in adult education and recreation througout the country. Most of the photographs depict, with great simplicity and warmth, men and women crafting such utilitarian objects as rugs, brooms, baskets, dolls, quilts, chairs, pieces of pottery, and musical instruments. In both projects, Ulmann intentionally rendered her subjects as types, not individuals, in order to universalize her themes. She was interested in a general human character, not specific instances of wealth, achievement, or standing.

Undoubtedly the American photographer whose work most closely paralleled that of Peter Henry Emerson was Edward S. Curtis, the noted chronicler of this country's Native Americans (fig. 37). Curtis's substantial body of work represents an ideal marriage of ethnography and naturalistic photography. Just like Emerson, he drew his primary inspiration from Nature (which he, likewise, usually capitalized), and he issued his photographs with extensive texts about the culture of his subjects. Capping off the similarity to Emerson's work was Curtis's use of the photogravure process to publish all of his work in his multivolume set *The North American Indian*. President Theodore Roosevelt, who wrote the foreword to the first volume, concisely described the author by stating, "In Mr. Curtis we have both an artist and a trained observer."[53]

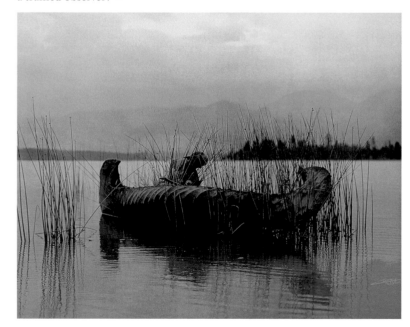

37. | Edward S. Curtis
The Rush Gatherer, Kutenai
1906, photogravure, collection of Christopher Cardozo

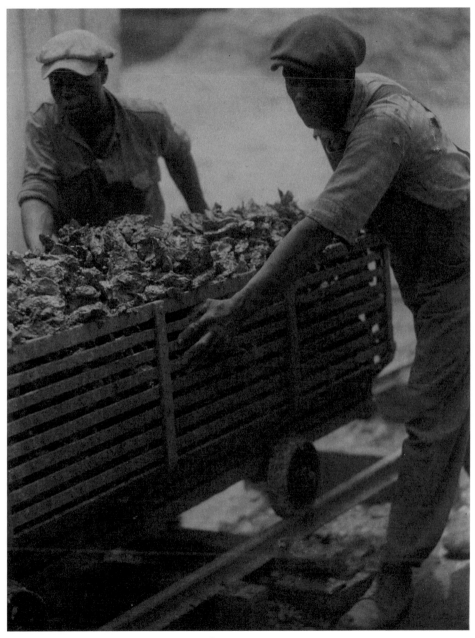

38. | **Doris Ulmann**
Untitled

c. 1925, platinum print, Minneapolis Institute of Arts, Robert C. Winton Fund

39. | Edward S. Curtis
Assiniboin Mother and Child
1926, photogravure, Minneapolis Institute of Arts, gift of Joe Langer

Curtis grew up in rural Wisconsin, ingraining in him a deep and abiding appreciation of nature. In 1899, after establishing himself as a photographer in Seattle, he went on his first expedition, to Alaska, which, fittingly, numbered among its party the nature writers John Muir and John Burroughs. Four years later, in 1903, Curtis began publishing *The North American Indian*, a mammoth project that eventually totaled twenty volumes comprising twenty-two hundred photogravures and nearly four thousand pages of text. This in-depth series showed Curtis as someone who wanted not only to gather material on Native Americans, but as a devoted artist/ethnographer who was willing to spend decades interacting with his subjects. The last volume did not appear until 1930, after Curtis had sacrificed his marriage, business, and all his finances to it.

Aware that the death of every elderly Indian represented the loss of some particular aspect of their culture, Curtis wished to record as much as humanly possible. Over the course of the project, he documented more than eighty different tribes west of the Mississippi River. Not content to merely make photographs, he and his assistants made over ten thousand recordings of Native American speech and music. His crew included an expert linguist interpreter and an editor from the Bureau of American Ethnology in Washington, D.C. But Curtis himself wrote virtually all of the text. Writing beside a mountain brook, he stated, "The word-story of this primitive life, like the pictures, must be drawn direct from Nature. Nature tells the story, and in Nature's simple words I can but place it before the reader. In great measure it must be written as these lines are—while I am in close touch with the Indian life."[54]

Curtis's text covered every phase of Native American life, tribe by tribe, chapter by chapter. He wrote about their births, marriages, deaths, burials, ceremonies, dances, songs, clothing, costumes, food, hunting practices, dwellings, language, crafts, farming, spiritual beliefs, and a host of other cultural, racial, and social topics. As an example of the depth to which he went, the last volume, on Alaskan Eskimos, included six pages on the construction, dedication, use, and equipment of kayaks, plus diagrams of six different models. The largest volume, on the Kawakiutl tribe of British Columbia, ran to nearly four hundred pages, including nine on vocabulary alone.

Despite the details of Curtis's text, his images avoided becoming a technical catalogue of the North American Indian. He was intent upon making photographs of beauty and sentiment that stood as works of art in their own right. To this end, Curtis skillfully used selective focus and kept his compositions clean and simple (fig. 39). He employed the aesthetics of naturalistic photography as a way of achieving his larger goal of preserving knowledge, both written and visual, of Native American culture.

Conclusion

In 1889 when Peter Henry Emerson issued his tract *Naturalistic Photography*, he was hoping to change the course of photography forever, and he did. His concepts most influenced American photography until about World War I, when modernism began to dominate all the arts. Yet late practitioners like Ulmann and Curtis continued making naturalistic photographs until about 1930, extending the movement to a full forty years. Even Alfred Stieglitz conceded that naturalistic photography still had currency at this late date. In 1933, three years before Emerson died, Stieglitz wrote his last letter to the elder photographer. He concluded it by saying, "Not long ago I had your portfolio of gravures in my hand and also your book *Naturalistic Photography*. Both took me back many years—and both seem still alive."[55]

Notes

1. The only publications on the subject are the excellent but modest catalogues Mary Panzer, *Philadelphia Naturalistic Photography, 1865–1906* (New Haven: Yale University Art Gallery, 1982), and *Naturalistic Photography, 1880–1920* (Winchester, Massachusetts: Lee Gallery, 1998).

2. P. H. Emerson, *Pictures from Life in Field and Fen* (London: George Fell and Sons, 1887), 13.

3. Ibid., 10.

4. P. H. Emerson, *Naturalistic Photography for Students of the Art* (London: Sampson Low, Marston, Searle and Rivington, 1889), 22.

5. Ibid., 245.

6. Nancy Newhall, *P. H. Emerson: The Fight for Photography as a Fine Art* (Millerton, New York: Aperture, 1975), 92.

7. Emerson, *Naturalistic Photography*, 251.

8. P. H. Emerson, *Wild Life on a Tidal Water: The Adventures of a House-Boat and Her Crew* (London: Sampson Low, Marston, Searle and Rivington, 1890), viii.

9. P. H. Emerson, "Our English Letter," *American Amateur Photographer*, vol. 1 (December 1889): 243.

10. P. H. Emerson, *The Death of Naturalistic Photography* (privately published, 1890).

11. "The Exhibition of the Photographic Society of Philadelphia," *Philadelphia Photographer*, vol. 23 (January 16, 1886): 60.

12. "Philadelphia Exhibition," *Anthony's Photographic Bulletin*, vol. 20 (May 15, 1889): 306.

13. "Naturalistic Photography" [book review], *Anthony's Photographic Bulletin*, vol. 20 (June 8, 1889): 350.

14. Quoted in P. H. Emerson, *Naturalistic Photography for Students of the Art*, 2nd ed. (New York: E. & F. Spon, 1890), reviews page 8.

15. "Naturalistic Photography" [book review], *American Amateur Photographer*, vol. 11 (September 1899): 407.

16. Theodore Eitel, "The Forest and the Camera," *Photo Era*, vol. 25 (September 1910): 114.

17. Quoted in Emerson, *Naturalistic Photography*, 1890, reviews page 6.

18. "Wild Life on a Tidal Water" [book review], *Nation*, vol. 52 (February 19, 1891): 165.

19. P. H. Emerson, "Our English Letter," *American Amateur Photographer*, vol. 1 (November 1889): 201.

20. George Davison, "Impressionism in Photography," *Wilson's Photographic Magazine*, vol. 28 (February 21, 1891): 124.

21. "Naturalistic Photography," *Wilson's Photographic Magazine*, vol. 32 (March 1895): 109–11.

22. P. H. Emerson, "Bubbles," *Photographic Times*, vol. 32 (September 1900): 420 and 422.

23. Alfred Stieglitz, "My Favorite Picture," *Photographic Life*, vol. 1 (July 1899): 12.

24. P. H. Emerson to Alfred Stieglitz, June 20, 1888. Beinecke Rare Book and Manuscript Library, Yale University.

25. Alfred Stieglitz, quoted in P. H. Emerson, "Our English Letter," *American Amateur Photographer*, vol. 1 (November 1889): 198–201.

26. Alfred Stieglitz, "Naturalistic Photography," *Camera Notes*, vol. 3 (October 1899): 88.

27. William Dassonville, "Individuality in Photography," *Overland Monthly*, vol. 40 (October 1902): 339.

28. Eitel, "Forest and the Camera," 107.

29. Rudolf Eickemeyer, Jr., "How a Picture Was Made," *Camera Notes*, vol. 1 (January 1898): 63–64.

30. R. B. B. "Rambling," *Camera*, vol. 24 (January 1920): 10.

31. Sadakichi Hartmann, "Along the Seashore," *Metropolitan* (September 1904): 705.

32. Rudolf Eickemeyer, Jr., *The Old Farm* (New York: R. H. Russell, 1901), unpg.

33. Sadakichi Hartmann, "Introduction" in Rudolf Eickemeyer, Jr., *Winter* (New York: R. H. Russell, 1903), iii.

34. Henry Troth, "Amateur Photography at its Best," *Ladies' Home Journal*, vol. 14 (April 1897): 19.

35. Eitel, "Forest and the Camera," 107.

36. "Cloud Negatives," *Photographic Times*, vol. 23 (September 8, 1893): 493.

37. "Down South," *Wilson's Photographic Magazine*, vol. 37 (November 1900): 497.

38. Andrew Pringle, "Landscape with Figures," in W. I. Lincoln Adams, ed., *Sunlight and Shadow: A Book for Photographers, Amateur and Professional* (New York: Baker and Taylor, 1897), 37.

39. Sydney Allen [Sadakichi Hartmann], "The Pond," *Metropolitan* (October 1906): 11.

40. J. Traill Taylor, "Fuzzyness and Naturalism," *American Annual of Photography 1891*, 241.

41. Frederick Graves, "The Art of Focusing," *Camera*, vol. 12 (September 1908): 355.

42. "The Focus Question," *Camera*, vol. 22 (November 1918): 577.

43. F. A. Waugh, "Landscape Photography," *Photo Miniature*, vol. 3 (April 1901): 14.

44. Eitel, "Forest and the Camera," 115.

45. Frances S. and Mary E. Allen, "Prize-Winners' Accounts of Themselves," *Photo Beacon*, vol. 6 (March 1894): 104.

46. Mabel Osgood Wright, "Naturalness in Photography," *Photographic Times*, vol. 30 (October 1898): 434.

47. Rudolf Eickemeyer, Jr., quoted in "Rudolf Eickemeyer, Jr., and His Work," *Photographic Times*, vol. 26 (February 1895): 77–78.

48. Harry G. Phister, "The Value of Clouds," *American Annual of Photography 1919*, 242.

49. David J. Cook, "Landscape Photography," *Photographic Times*, vol. 22 (September 1909): 112.

50. Charles H. Caffin, *Photography as a Fine Art: The Achievements and Possibilities of Photographic Art in America* (New York: Doubleday, Page, 1901), 166.

51. A. Horsley Hinton, "Naturalism in Photography," *Camera Notes*, vol. 4 (October 1900): 90.

52. David J. Cook, "Landscape Photography," *Photo Era*, vol. 22 (September 1909): 111.

53. Theodore Roosevelt, "Foreword," in Edward S. Curtis, *The North American Indian* (Seattle: Edward S. Curtis, 1907–30).

54. Curtis, ibid., xiv.

55. Alfred Stieglitz to P. H. Emerson, October 9, 1933. Beinecke Rare Book and Manuscript Library, Yale University.

Plates

40. | **John G. Bullock**
Untitled

c. 1900, platinum print, Minneapolis Institute of Arts, McClurg Photography Purchase Fund

41. | Edward S. Curtis
Hasen Harvest, Qahatika
1907, photogravure, Minneapolis Institute of Arts, Ethel Morrison Van Derlip Fund

42. | William E. Dassonville

A November Day

c. 1900, platinum print, Minneapolis Institute of Arts, McClurg Photography Purchase Fund

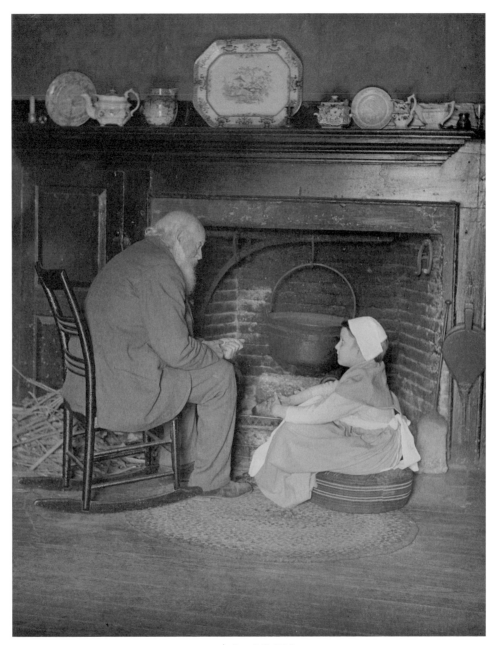

43. | Sarah J. Eddy
When I Was a Boy
c. 1900, platinum print, Minneapolis Institute of Arts, McClurg Photography Purchase Fund

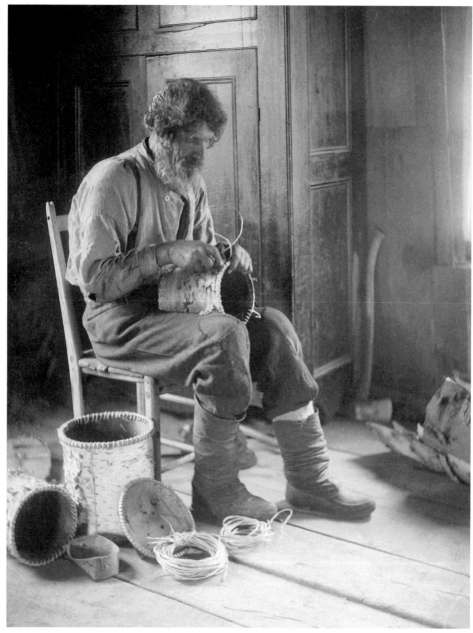

44. | Rudolf Eickemeyer, Jr.
The Basketmaker
c. 1900, platinum print, Minneapolis Institute of Arts, McClurg Photography Purchase Fund

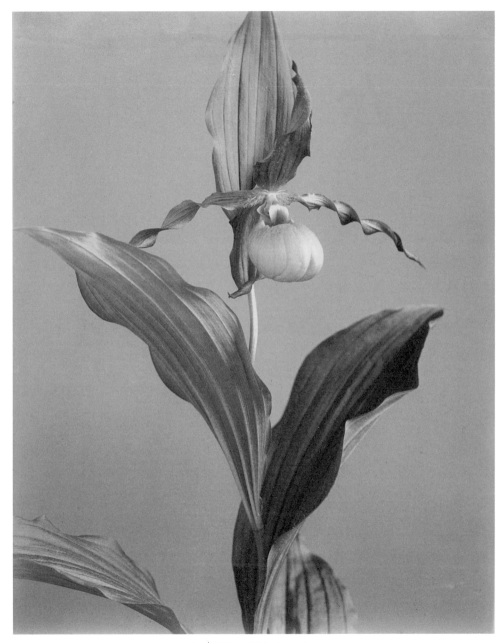

45. | Edwin Hale Lincoln
"Cypripedium Parviflorum," Variety Pubescens: Large Lady's Slipper
1931, platinum print, Minneapolis Institute of Arts, gift of Richard and Susan Nunley

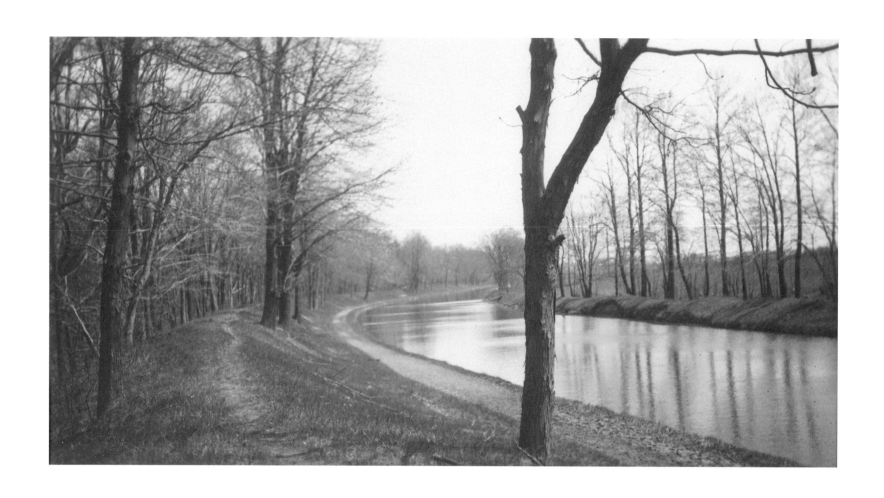

46. | William J. Mullins
Untitled
c. 1900, platinum print, Minneapolis Institute of Arts, McClurg Photography Purchase Fund

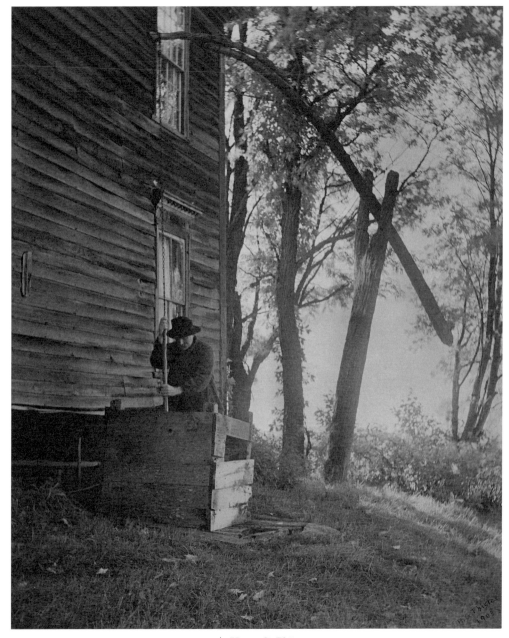

47. | **Harry G. Phister**
The Old Well

1908, platinum print, Minneapolis Institute of Arts, McClurg Photography Purchase Fund

48. | **James Bartlett Rich**
Untitled
c. 1900, platinum print, Minneapolis Institute of Arts, McClurg Photography Purchase Fund

49. | Henry Troth
August Morning, Crum Creek
c. 1900, platinum print, Minneapolis Institute of Arts, McClurg Photography Purchase Fund

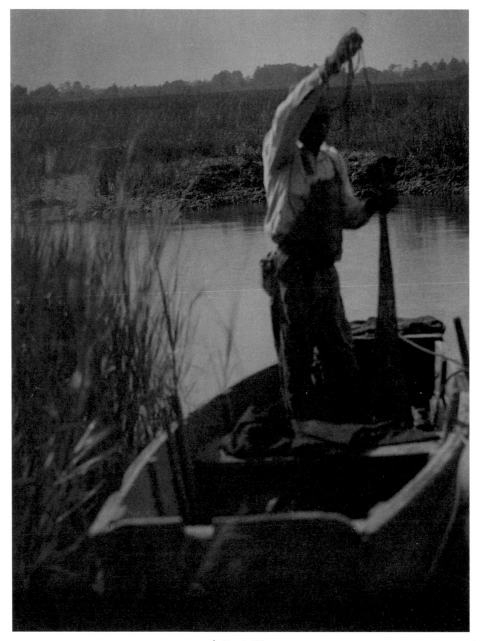

50. | **Doris Ulmann**

Fisherman, Near Brookgreen Plantation, Murrells Inlet, South Carolina

c. 1930, platinum print, Minneapolis Institute of Arts, Walter R. Bollinger Fund

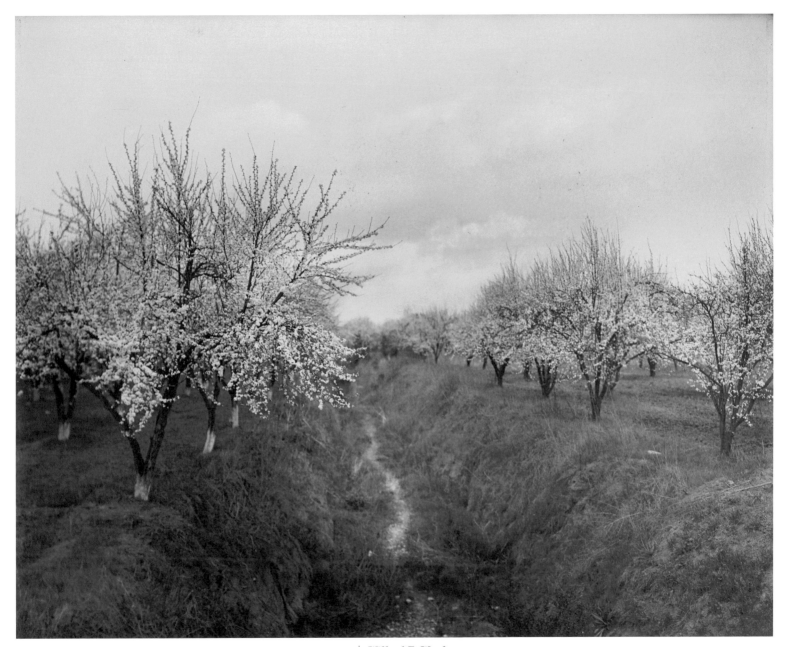

51. | **Willard E. Worden**

Blossoming Orchard

c. 1910, gelatin silver print, Minneapolis Institute of Arts, McClurg Photography Purchase Fund

Biographies

Frances and Mary Allen
1854–1941 and 1858–1941

The Allen sisters were born and lived virtually their whole lives in Deerfield, Massachusetts, an idyllic village in the western part of the state. They were close lifelong companions, residing together (often with other family members) and jointly producing their photographic work.

Frances and Mary each graduated from the State Normal School (Westfield, Massachusetts) in 1876 and subsequently taught school for a time. In the 1880s, however, they both began to lose their hearing, prompting them to give up teaching and take up photography. Though they were part of a well-off Deerfield family, the sisters turned their new interest into a serious livelihood by selling photographs as both original prints and for reproduction in magazines and books. Additional income was generated by making studio portraits.

The work of the Allen sisters appealed to a wide audience at the turn of the twentieth century. Individuals interested in the Arts and Crafts movement were drawn to Deerfield (known for its needlework and other craft industries), where they visited the Allen studio to buy images that captured the town's Colonial Revival architecture and lifestyle. The Allens also provided many photographic illustrations for the popular press, including *Good Housekeeping* magazine and books on New England. Among the most artistic of the books they illustrated was Sara Andrew Shafer's *A White-Paper Garden* (1910). In it Shafer wrote month-by-month nature reveries, which were accompanied by the Allens' evocative landscapes of the appropriate season.

The Allen sisters issued at least seven sales catalogues of their work between 1904 and 1920. These unillustrated checklists offered platinum prints, in different sizes, of landscapes, figure studies, children, and "Old Deerfield." After their trips to the United Kingdom in 1909 and California in 1916, they also offered images of these locales.

The Allens enjoyed artistic as well as commercial success during their lifetimes. In 1901 they presented an exhibition of their work at the Photographic Society of Philadelphia, one of the country's leading camera clubs. The same year, photographer Frances Benjamin Johnston included the Allens in her series of articles in the *Ladies' Home Journal* on the "Foremost Women Photographers of America." And in 1913 a Boston art gallery presented another exhibition of exclusively their work.

Unfortunately, by about 1920 the sisters had not only gone deaf but had also lost most of their sight, making it impossible to continue photographing. Nonetheless, they continued to exhibit and sell their work for another fifteen years. Deeply committed to each other, Frances and Mary Allen died within four days of one another in February 1941.

———

Suzanne L. Flynt, *The Allen Sisters: Pictorial Photographers, 1885–1920* (Deerfield, Massachusetts: Pocumtuck Valley Memorial Association, 2002).

John G. Bullock
1854–1939

John G. Bullock was born in Wilmington, Delaware, into a prominent Quaker family of pharmacists. Dutifully, he acquired an orthodox Quaker education at Haverford College (Haverford, Pennsylvania) and, after additional schooling, began working at his family's Philadelphia pharmacy in 1879.

Bullock became interested in photography in 1882, when he purchased a camera, joined the Photographic Society of Philadelphia, and studied with the veteran

photographer John C. Browne. Bullock rose to prominence in the society within a few years, when he began serving as its vice president and subsequently its president. Along with a few other leading members, Bullock helped organize the three Philadelphia Photographic Salons of 1898–1900, which were the most artistic exhibitions of photographs of the time.

Bullock's work focused on the landscape and rural life of the environs of Philadelphia. In 1901 the Camera Club of New York held an exhibition of his photographs along with those of fellow Philadelphians Robert S. Redfield and Edmund Stirling. The next year Bullock was designated a founding fellow of Alfred Stieglitz's exclusive group of photographers, the Photo-Secession. Stieglitz included Bullock's work in both the Secession's inaugural exhibition of 1902 at the National Arts Club in New York and its last show, seen at the Albright Art Gallery in Buffalo in 1910.

Bullock's artistic pursuits seemed to have slowed by the time he retired as a pharmacist in 1907. In 1915 he provided documentary photographs for a guidebook to historic Germantown, the suburb in which he lived. About ten years later he moved to West Chester, Pennsylvania, where he devoted his time to local history, until his death there in 1939.

———

Tom Beck, *An American Vision: John G. Bullock and the Photo-Secession* (New York: Aperture, in association with the Albin O. Kuhn Library and Gallery, University of Maryland, Baltimore County, 1989).

Edward S. Curtis
1868–1952

Edward Sheriff Curtis produced the most extensive documentation of Native American culture of the twentieth century. Published in twenty volumes, *The North American Indian* included more than two thousand photographic images and detailed texts on the lifestyles of over eighty tribes.

After growing up in rural Wisconsin, seventeen-year-old Edward Curtis moved with his family to St. Paul, Minnesota, where he began apprenticing with a photographer. A few years later, in 1887, the Curtises relocated again, to Puget Sound, Washington. In the early 1890s Edward became a partner in a Seattle photographic studio and by the end of the decade was the city's leading portrait photographer.

In contrast to Curtis's high-society studio clientele, the country's neglected indigenous population of Native Americans began drawing his interest in the late 1890s. In 1900 he went on expeditions to Montana, where he witnessed such sacred rituals as the Sun Dance, and to Arizona, where he photographed three separate tribes. Curtis was soon convinced that the American Indian deserved a mammoth documentary project that would require years of his time and financing far beyond his own resources. In 1906 he was fortunate to obtain substantial funding from J. Pierpont Morgan and the very next year published the first two volumes of *The North American Indian*. The books featured quality paper, letterpress-printed text, rich photogravure illustrations, and leather bindings.

Nonetheless, it took another twenty-three years and untold personal sacrifices for Curtis to finish the set. Due to the time he increasingly spent on the project, he eventually lost his Seattle studio and his wife. And despite Morgan's generosity, Curtis had to do additional fund-raising by frequent lecturing. In 1914 he released *Land of the Headhunters*, a film that was ethnographically valuable but financially a loss for him. In 1919 one of Curtis's daughters opened a photographic studio in Los Angeles, which became his new base and from where he published the remainder of *The North American Indian*. Its last volume appeared in 1930 and only about three hundred of the projected five hundred sets were issued.

After a short flurry of interest over the project's completion, little attention was paid it for the rest of the photographer's life. Curtis died in Los Angeles, poor and unrecognized, in 1952.

William E. Dassonville
1879–1957

Born in Sacramento, William Dassonville moved with his family in the mid-1880s to San Francisco, where he spent most of his life. There he made his living photographing people and manufacturing photographic paper. He also pursued creative photography by sensitively picturing California's wharves and landscape.

Dassonville opened his first portrait studio in 1901 with Oscar Maurer but struck out on his own shortly thereafter. The 1906 San Francisco earthquake destroyed his business, prompting him to leave the city to photograph in the Sierra Nevada. The next year, however, he reestablished his studio in San Francisco.

Dassonville satisfied his artistic drive by associating with local amateurs who were similarly inclined. He joined the California Camera Club, where he soon became an officer and a regular exhibitor. His work was included in the first three San Francisco photographic salons (1901–3), and he was privileged to serve on the jury for the fifth salon. He had four one-person exhibitions between 1902 and 1907, at the camera club and at Paul Elder and Company, a leading local bookshop. In 1915 he received an honorable mention in the photography display of San Francisco's Panama-Pacific Exposition.

Apparently dissatisfied with the quality of commercially available photographic papers, Dassonville began experimenting with his own in about 1920. Four years later he sold his portrait studio to establish the Dassonville Company, manufacturer of "Charcoal Black." This specially coated bromide paper—featuring rich blacks, a matte surface, and a parchment-like base—became widely favored by amateurs, professionals, and Ansel Adams, among other prominent photographers. Dassonville's business weathered the Great Depression, but financial difficulties forced him to sell it in 1941. He temporarily helped oversee the continued manufacture of his paper at the East Coast firm that bought him out, but "Charcoal Black" disappeared from the market by 1949.

Once back in the Bay Area, Dassonville worked as a medical photographer at a university hospital. He died in San Francisco in 1957.

———

Susan Herzig, Paul Hertzmann, and Peter Palmquist, *Dassonville: William E. Dassonville, California Photographer [1879–1957]* (Nevada City, California: Carl Mautz Publishing, 1999).

Sarah J. Eddy

1851–1945

Sarah J. Eddy began exhibiting photographs in 1890, at nearly forty years of age. She was born in Boston and studied painting and sculpture at the Pennsylvania Academy of Fine Arts and New York's Art Students League. From the 1890s until her death she resided in Portsmouth, Rhode Island, a coastal town southeast of Providence.

Eddy's photographs appeared regularly in American and foreign exhibitions until about 1910. Her work was displayed at camera club exhibitions in Providence and Hartford, Connecticut, but most regularly at the Boston Camera Club, where she was a member. She exhibited at photographic salons in Philadelphia, Pittsburgh, Chicago, Minneapolis, and Toronto. Her most important exhibitions were the "New School of American Photography" and the selection of American women photographers at the Paris Universal Exposition of 1900. The first, organized by Boston photographer F. Holland Day, was presented in London in 1900 and Paris in 1901. The second, gathered by Frances Benjamin Johnston, was featured at the Exposition's Congrès International de Photographie.

Eddy preferred photographing children, women, and animals, in both rural and domestic scenes. In 1894 she wrote and illustrated the short article "A Good Use for the Camera" for the *American Annual of Photography*, in which she described finding willing subjects as she traveled the country in her carriage. After detailing the making of a handful of successful pictures, she concluded that her personal interactions were as rewarding as the finished images: "We enter into sympathetic relations with the people who furnish us the pictures. We are grateful to them and they are *very* grateful to us. We meet on common ground."

Eddy's holistic attitude was evident in her other activities, as an author and founder of humane societies. Between 1899 and 1938 she wrote or compiled five children's books on animals and their care. Most widely read were *Friends and Helpers* and *Alexander and Some Other Cats*, both featuring her sympathetic text and photographic illustrations. Eddy worked with humane societies for half a century; in the 1890s she helped found the Rhode Island Humane Education Society, and at her death she was the director of the Massachusetts Society for the Prevention of Cruelty to Animals.

Sarah J. Eddy died in her Portsmouth home, on March 29, 1945, at age 93.

———

"Miss Sarah A. [*sic*] Eddy: Author of Books on Animals, 93, Active in Humane Societies," *New York Times*, March 31, 1945, 19.

Rudolf Eickemeyer, Jr.

1862–1932

Rudolf Eickemeyer, Jr., was born in Yonkers, New York, where he lived his entire life. He worked as a professional portrait photographer in Manhattan, illustrated numerous books and magazine articles, and was active in camera clubs.

As a young adult Eickemeyer worked as a draftsman in the business of his father, a successful inventor of electrical machines. He purchased his first camera in 1884 and five years later helped found the Yonkers Camera Club. By 1894 Eickemeyer was among America's best-known amateur photographers. In that year alone he had a one-person exhibition at the Photographic Society of Philadelphia and his prints won top honors at both the seventh Joint Exhibition and England's Royal Photographic Society. He was further honored by the Linked Ring (London) when he and Alfred Stieglitz were elected the first Americans to this exclusive group of international photographers.

In 1895 Eickemeyer's father died and Rudolf quit the family business to become a professional photographer. Initially he and James L. Breese operated a portrait business called the Carbon Studio. Between 1900 and 1915 he worked variously at the Campbell Art Company and Davis and Eickemeyer. In 1902 Eickemeyer produced a suggestive image of the starlet Evelyn Nesbit, which was widely circulated a few years later when Nesbit's husband went on trial for the murder of architect Stanford White, with whom Nesbit allegedly had an affair.

Eickemeyer's personal, creative work consisted largely of landscapes, photographed in all seasons and often with an expansive foreground. This work figured prominently in a one-person exhibition he had at the Camera Club of New York in 1900 and a large retrospective at New York's Anderson Galleries in 1922.

Landscape work by Eickemeyer was reproduced in a few popular books by nature authors. His most significant illustrations, however, appeared in four large-format volumes issued by the art publisher R. H. Russell: *In and Out of the Nursery* (1900), a children's book; *Down South* (1900), on southern blacks; *The Old Farm* (1901); and *Winter* (1902). In 1929 and 1930 Eickemeyer donated much of his life's work with an endowment for its maintenance to what is now the Smithsonian's National Museum of American History. He died a few years later.

———

Mary Panzer, *In My Studio: Rudolf Eickemeyer, Jr., and the Art of the Camera, 1885–1930* (Yonkers, New York: Hudson River Museum, 1986).

Theodore Eitel

1867–1955

Theodore Paul Eitel was born on Christmas Eve in Louisville, Kentucky, where he lived his entire life. He photographed wooded landscapes almost exclusively.

Eitel made his living as a businessman but enjoyed amateur musical and visual pursuits. In 1890 he organized and served as first bandmaster for the Louisville Liederkranz, a small band that played German and American military music. By 1903 Eitel was exhibiting photographs; that year he showed three landscapes in the first Minneapolis Photographic Salon. Louisville apparently did not have a camera club at this time, allowing him the freedom to work on his own. He frequently took his medium-format, Graflex camera on the streetcar to the edge of the city to photograph trees, birch being his favorite.

Eitel did not exhibit extensively, but his work was regularly seen in the photographic press. The Boston-based monthly *Photo Era* regularly reproduced his pictures during the first two decades of the twentieth century.

In September 1910 Eitel wrote a lead article for the magazine on photographing in the forest, stressing his love of trees and the importance of good composition. Most impressive was his long run of images in the *American Annual of Photography*. Between 1905 and 1926 this leading publication reproduced at least one of Eitel's images every single year.

Eitel died in a Louisville nursing home in July 1955.

Peter Henry Emerson
1856–1936

Peter Henry Emerson was a major nineteenth-century English photographer who spearheaded naturalistic photography at home and abroad. He extensively photographed and wrote about the landscape and inhabitants of his country's southeastern coastline. Most of his exquisite images were issued as photogravures, in limited-edition portfolios and books.

Emerson (a distant relative of Ralph Waldo Emerson) was born in Cuba in 1856 to an American father and an English mother. Early on he showed an interest in sports and the outdoors. When he was eight his family moved back to the United States for a brief time before settling in England following the death of his father. He studied medicine at King's College in London and received the equivalent of an M.D. in 1879. Shortly thereafter he took an advanced medical degree and then worked as a physician for a few years.

In 1882 Emerson began to photograph and exhibit his work. The next year, he joined England's premiere group of photographers, later renamed the Royal Photographic Society, with which he became closely associated. In 1885 he cruised for the first time through the Norfolk Broads, a region that captivated him for many years. *Life and Landscape on the Norfolk Broads*, his deluxe book of forty platinum prints, appeared the next year, to great praise.

Emerson's subsequent publications, however, all were illustrated with images in photogravure, a high-quality photomechanical process. Photogravures are photographic images rendered in printer's ink, essentially photo-etchings. Between 1887 and 1895 Emerson issued two portfolios and five additional books, beginning with *Idyls of the Norfolk Broads* and ending with *March Leaves*. He functioned like an artistic anthropologist, making beautiful, idyllic images accompanied by substantial and insightful text on the lifestyles of his subjects. In 1890 Emerson himself learned the photogravure process, setting up his own press and making the prints for his publications.

Emerson defined naturalistic photography in 1889, when he issued his unillustrated tract *Naturalistic Photography for Students of the Art*. In it he argued for photography as a fine art, declared nature the standard for all pictures, and explained his practice of "differential focusing." This involved focusing the image sharply in the center and softly on the edges, a method he believed more closely approximated normal human vision. Amazingly, only a year after his book was published, Emerson abandoned his belief that photography was an art and issued the black-bordered pamphlet *The Death of Naturalistic Photography*. Nonetheless, a whole generation of advanced amateurs were inspired to begin making creative photographs.

In 1895 the Royal Photographic Society (RPS) awarded Emerson its prestigious Progress Medal for artistic achievement. Five years later the RPS gave him a retrospective of nearly 150 photographs. After this show Emerson ceased exhibiting and allowing his work to be published, though he continued photographing. Throughout most of Emerson's career he issued medals to photographers whose work he admired, beginning with Alfred Stieglitz and ending with Brassaï.

Late in life Emerson wrote a history of photography, the manuscript for which has never been found. In 1936 he died, a day short of his eightieth birthday.

—

Nancy Newhall, *P. H. Emerson: The Fight for Photography as a Fine Art* (Millerton, New York: Aperture, 1975).

J. H. Field
1869–1936

Julius Herman Field was born in Waupun, Wisconsin, on February 19, 1869, to Norwegian immigrants. Initially Field practiced carpentry with his father but eventually worked for a local photographer. In 1894 he purchased a studio in nearby Berlin, Wisconsin, setting up a portrait business. He hired a female assistant, whom he later married and had one child with.

From about the turn of the twentieth century to World War I, Field's creative photographs were widely seen in exhibitions and photographic periodicals. He showed at the 1900 Philadelphia Photographic Salon, the first three American Photographic Salons (which traveled from 1904 to 1907), the Panama-Pacific Exposition in San Francisco (1915), and also in European exhibitions. He won numerous awards and joined the populist Salon Club, a rival organization to Alfred Stieglitz's elitist Photo-Secession. His images were most frequently reproduced in the periodicals *Camera*, *Photo Era*, and *Photographic Times*.

Field was a small, quiet man of frail health and poor hearing. Drawn by the mild climate and an article he read in the *Saturday Evening Post*, he moved his family to Fayetteville, Arkansas, in 1913. There he reestablished a portrait studio on the town square and continued to be assisted by his wife, producing portraits and other photographs for illustration. In 1915 local author William R. Lighton issued his book *Happy Hollow Farm*, illustrated with photographic images reportedly by Field but uncredited in the publication. Lighton had written the *Post* article about Fayetteville and by this time had become friends with Field. Field's pictures were reproduced in such popular magazines as the Arts and Crafts journal *Craftsman* in June 1916 and *Good Housekeeping* in the early 1920s.

In 1925 Field had a one-person exhibition of his work at the art department of the University of Arkansas in Fayetteville. Eight years later he closed his studio, although he continued to make personal work, largely landscapes shot in the nearby Ozark wilderness. Field died on January 14, 1936, after a series of heart attacks.

—

The Gentle Eye: The Photography of J. H. Field (Little Rock, Arkansas: Old State House, 1990).

Martha Hale Harvey

1862–1949

Martha Hale Harvey, about whom we know little today, was active as an artist during the 1880s to 1930s around Gloucester, Massachusetts. Born and bred there, she lived most of her adult life in the nearby village of Annisquam, on Ipswich Bay.

In 1886 Harvey went to Holland to study painting with her new husband, George Wainwright Harvey. Upon returning, they set up and maintained adjoining studios, influencing each other's work and treating many of the same subjects. They earned their living painting and photographing the landscape and people of Cape Ann, where Winslow Homer also spent much time in the 1880s. Harvey extensively surveyed the area with her camera, turning her sensitive eye on the surf, harbors, fishing schooners, sailing vessels, landmarks (like lighthouses and churches), and the inhabitants (both as personalities and types). Working with an eight-by-ten-inch camera allowed her to produce large platinum prints, always delicate in tone and strong in composition. She occasionally even worked after sunset, photographing moody coves by moonlight. Content to make images for only herself and the buying public, she apparently did not join area camera clubs or participate in their exhibitions.

Harvey outlived her husband by nearly twenty years, dying in 1949.

Edwin Hale Lincoln

1848–1938

Edwin Hale Lincoln is known for his extensive series of flower photographs. Between 1904 and 1914 he self-published *Wild Flowers of New England*, eight volumes (issued both loose and bound) of four hundred original platinum prints.

Lincoln was born on January 2, 1848, in Westminster, Massachusetts. At fourteen years of age he served as a drummer boy in the Union Army, during the American Civil War. He began his photographic career in 1876, as a salesman and partner in a photographic business in Brockton, Massachusetts. In 1883 he began photographing Berkshire estates for their wealthy owners and wooden yachts sailing at Newport, Rhode Island.

In 1893 Lincoln moved to Pittsfield, Massachusetts, where he commenced his interest in wildflowers. A sensitive naturalist, he was always careful not to destroy his subjects or their habitat. Though he dug up the flowers he photographed, he lovingly nurtured them while in his care and returned them to their natural settings when done. Lincoln preferred working in his home studio, where he used an eight-by-ten-inch camera and could more easily control the light. All of his photographs are contact prints made directly from his large-format negatives.

To support himself and his family, Lincoln sold his finished portfolios and books largely to institutional collections. From 1902 to 1921 he also worked as the resident caretaker on a wealthy estate in Pittsfield.

In 1931 Lincoln issued his last set of photographs, *Orchids of the North Eastern United States*. Comprising ninety-seven platinum prints in two volumes, it rendered all the known orchids of the region, printed life size. At about this time Lincoln was honored by both the Massachusetts Horticultural Society and the American Orchid Society for his devoted work with wildflowers.

Late in life Lincoln was involved with veteran affairs and reportedly also still photographed. In 1938, at ninety years of age, he was still in good health but was struck and killed by an automobile in Pittsfield.

———

George Dimock, *A Persistence of Vision: Photographs by Edwin Hale Lincoln* (Lenox, Massachusetts: Lenox Library Association, and Pittsfield, Massachusetts: Berkshire Museum, 1981).

Clarence B. Moore

1852–1936

Clarence Bloomfield Moore was best known for his archaeological work on Native American burial sites in the Deep South, publishing many books on the subject from the 1890s to 1920s. During the 1890s he was also particularly active as a photographer, making a name for himself with his genre scenes of black children.

Moore graduated from Harvard University in 1873 and then traveled in Europe and explored South America, sometimes by raft and horseback. In 1881, on the death of his father, he inherited his family's Philadelphia business, the Jesip and Moore Paper Company. Due to an eye injury, however, Moore did not assume business responsibilities and, instead, began cultivating his interest in science.

In 1888 Moore joined the Photographic Society of Philadelphia, following the example of his uncle J. Ridgeway Moore, an active member of the Camera Club of New York. For the next decade, Moore exhibited his work regularly and authored articles for both the general and photographic press. He wrote on such topics as portraiture, luck in photography, and blacks as subjects for the magazines *Outing*, *Photo Beacon*, and *American Amateur Photographer*. In February 1892 he contributed the lengthy article "Leading Amateurs in Photography" to *Cosmopolitan*, in which he detailed the work and exhibition records of a dozen photographers, including Alfred Stieglitz and his fellow Philadelphians John G. Bullock and Robert S. Redfield.

Moore's own photographs were seen in many exhibitions in North America and Europe. In this country he exhibited in Chicago, Syracuse, Rochester, and Washington, D.C., and he participated in three of the Joint Exhibitions as well as the Philadelphia Photographic Salon of 1898. He sent his photographs across the Atlantic to venues in London, Glasgow, Paris, and Hamburg. Undoubtedly his most important exhibition was a one-person show at the Camera Club of New York in 1897. Here he showed marines, landscapes, and figure studies, many of which were positively reviewed in the club's prestigious quarterly *Camera Notes*.

Moore seems to have been heavily dependent on the inspiration of J. Ridgeway Moore, for he abandoned photography after his uncle's death in 1901. Subsequently he devoted himself full-time to archaeology.

William J. Mullins

1860–1917

William James Mullins was born in Steubenville, Ohio, and worked for a time as a chemist for the Standard Oil Company. Artistically, he initially painted and developed friendships with such figures as Louis Comfort Tiffany.

By the late 1890s, however, he had shifted his focus to photography and soon became known for his small, intimate landscapes, rendered in the subtle tonalities of platinum.

Mullins lived in the small town of Franklin, Pennsylvania, in the northwestern part of the state. Despite his isolated location (more than sixty miles from Pittsburgh), he associated with two prominent groups of photographers in New York City. He joined the Camera Club of New York and showed in their members' exhibitions in 1901, 1902, and 1905. More impressively, he became a member of the Photo-Secession, Alfred Stieglitz's elite cadre of artistic photographers. Stieglitz included work by Mullins in the Secession's major museum exhibitions in Pittsburgh, Philadelphia, and Buffalo. The last of these, presented at the Albright Art Gallery in 1910, featured a dozen of Mullins's landscape photographs.

Around 1900, more than a dozen of his images appeared in the pages of the *American Annual of Photography* and the monthly *Photographic Times*. He presented work at salons and camera club shows in Toronto, Vienna, and Washington, D.C. His last known exhibition appearances were at New York's Montross Art Galleries in 1912 and at Syracuse University in 1915.

Mullins died in 1917 at fifty-seven years of age.

Harry G. Phister
1873–?

According to Phister, he began photography in the "old albumen print days," suggesting that he became interested in the medium while in his teens. His photographic work and writings were seen in the first two decades of the twentieth century.

Harry G. Phister resided in Vernon, New York, a small upstate town about twenty miles east of Syracuse. From there he interacted with other creative amateurs by joining two groups that circulated albums and portfolios of members' work through the mail, the Camera Craftsmen and the Associates of Pictorial Photography. In addition, he sent his work to numerous exhibitions and publications. His photographs were seen at an international salon at the Stedelijk Museum in Amsterdam in 1908 and at

Philadelphia's 1913 Wanamaker exhibition, which was judged by Alfred Stieglitz. Between 1907 and 1918 reproductions of his work appeared in the monthly magazines *Camera* and *Photo Era*.

Phister wrote four short, illustrated articles for the *American Annual of Photography* that appeared between 1916 and 1919: "The Protective Mimicry of Nature," "Photographing Waterfalls," "Wild Bird and Nest Photography," and "The Value of Clouds." In all of them he discussed both subject and technique.

Phister most frequently photographed animals and landscapes, but he also turned his camera on flowers and children. In 1918 he claimed that he had specialized in shooting wild birds and their nests for a number of years.

William B. Post
1857–1921

William Boyd Post was a wealthy amateur who became a member of Alfred Stieglitz's Photo-Secession. He excelled at making subtle pictures of snow and water lilies, primarily in rural Maine.

Post was born in New York and spent his early adult years as a stockbroker. However, in 1897, shortly after the death of his father (also a broker), he sold his seat on the New York Stock Exchange and moved to Fryeburg, Maine, a small village where his family had summered for many years. He lived there for the rest of his life, off of investments and his inheritance.

Post began photographing in about 1885 and within three years was a member of New York's two leading camera clubs. Like most other creative photographers at the time, he initially made lantern slides, and in 1892 presented a one-person screening of them at the Society of Amateur Photographers of New York. Post befriended Alfred Stieglitz, a fellow club member, and showed him how to use the hand camera, equipment Stieglitz soon used to make some of his important early New York images. In 1896 Post helped found the Camera Club of New York, where a few years later he had a one-person exhibition of his platinum prints. He was privileged to see his images printed in photogravure in both the club's quarterly, *Camera Notes*, and its first portfolio, *American Pictorial Photography*.

In 1902 Stieglitz included work by Post in the New York exhibition "American Pictorial Photography Arranged by the Photo-Secession," an elite group that Post soon joined. Subsequently his photographs were seen in other major Photo-Secession shows, both at museums and its own Fifth Avenue gallery. In addition, Post regularly exhibited his work at home and abroad from 1893 to 1910. His images were accepted at photographic salons in Chicago, Cleveland, Denver, and Philadelphia. Among the foreign countries to which he successfully sent work were Canada, England, France, Germany, India, and the Netherlands.

Post built a significant collection of photographs by other artistic photographers, such an unusual activity at the time that it was the subject of a brief *Camera Notes* article in 1899. He acquired a number of pieces by Stieglitz, who also collected and whose advice he took. Unfortunately, Post's collection did not survive, but he is known to have had work by more than twenty photographers, including F. Holland Day, Robert Demachy, Rudolf Eickemeyer, Jr., A. Horsley Hinton, Gertrude Käsebier, and Clarence H. White.

After about 1910 Post increasingly lost touch with his photographic colleagues in New York. He did, however, write two articles on his favorite subjects for *Photo Era*, a Boston monthly. In 1910 he addressed snow and in 1914 water lilies.

Post died in his sleep at his Fryeburg home on June 12, 1921 (not in 1925, as most sources cite).

——

Christian A. Peterson, *The Quiet Landscapes of William B. Post* (Minneapolis: Minneapolis Institute of Arts, 2005).

Robert S. Redfield
1849–1923

Robert Stuart Redfield was one of Philadelphia's leading creative photographers around the turn of the twentieth century. He was particularly important to the success of the city's camera club and to exhibitions that it organized. His own work consisted primarily of outdoor genre scenes.

Redfield was born in 1849 in New York into a distinguished family of scientists. When he was twelve, they moved to Philadelphia, where Robert became interested in photography about five years later. However, it was not until

1881, after the introduction of photographic dry plates, that Redfield embraced the medium fully and joined the Photographic Society of Philadelphia.

Redfield's name is closely linked with this group, due to his long record of service to it. In 1883 he was elected secretary, a position he held for a decade and a half. Photographic magazines of the period frequently printed the extensive minutes he took of club meetings and other activities. In 1898 he became president, serving for three consecutive terms and taking the society to national prominence. Redfield also helped found the society's journal and served as its first editor. Additionally, he was instrumental in running the Joint Exhibitions (1887–94) and the Philadelphia Photographic Salons (1898–1901). Both were presented at the Pennsylvania Academy of Fine Arts and were the most significant photography shows of their time.

Redfield produced a strong and consistent body of work that was widely seen. He was particularly adept at posing children and adults in the country, making idyllic images of rural America. His work was included in such key exhibitions as the "New School of American Photography," gathered in 1900 by F. Holland Day, and the Photo-Secession's first exhibition, organized in 1902 by Alfred Stieglitz. Redfield was a founding member of the Secession, Stieglitz's handpicked group of advanced camera workers. Redfield also was privileged in 1901 to show with his fellow Philadelphians John G. Bullock and Edmund Stirling in a three-man show at the Camera Club of New York. His photographs were seen in more than thirty exhibitions, both domestic and foreign, from 1885 to 1905.

After 1905 many artistic photographers began making pictures that looked less and less like camera-generated images. Redfield did not share this new interest in soft-focus and hand-manipulated effects and quietly retreated from the scene. He did, however, continue to use his camera for family portraits and life around Wayne, Pennsylvania, and Cape Cod.

Joseph T. Keiley, "Robert S. Redfield and the Photographic Society of Philadelphia," *Camera Notes*, vol. 5 (July 1901): 59–61.

James Bartlett Rich
1866–1942

Born in Philadelphia into a wealthy family, James Bartlett Rich pursued personal interests without significant financial concerns. Nonetheless, he operated a few businesses during his life as well as creating personal photographic work.

Rich initially got caught up in the bicycling craze that swept the nation at the end of the nineteenth century. He joined a local club and by 1890 had biked over 4,500 miles. His expertise with bicycles eventually led him into business, importing and selling them.

In 1901 Rich sold his bicycle concern to begin a business based on his new passion for photography. He established a commercial studio in downtown Philadelphia, concentrating on product and location work rather than portraiture. In 1908 he was hired to accompany an expedition to Yellowstone National Park, where he photographed the landscape and Native Americans. Despite operating his studio for forty years (at a number of locations), little of Rich's commercial work has survived.

On the other hand, many of Rich's personal, creative photographs exist. Almost invariably this work features landscapes, waterways, and small villages. Initially Rich enjoyed bicycling out of Philadelphia with a portable camera to find his quiet rural subjects. However, he was the first among his friends to purchase an automobile and quickly began using it to find additional material for his camera. Beyond his home state, he drove with his equipment through New York, New Jersey, Delaware, Maryland, and Virginia. Back home he also repeatedly photographed Philadelphia's large Fairmount Park, in all seasons.

Rich apparently was happy working alone, as he did not join a camera club, which was the normal practice of artistic photographers at the time. He did, however, successfully submit his pictures to a few competitive public exhibitions. In 1912 his work was seen in a show sponsored by the Eastman Kodak Company in New York. And the next year examples were included in the eighth annual photography exhibition at Philadelphia's John Wanamaker department store, which was judged by Alfred Stieglitz.

Rich remained active as a professional photographer until shortly before his death in 1942.

Charles Isaacs, "James Bartlett Rich (1866–1942)," in *Reflections on 19th-Century Landscape Photography* (Bethlehem, Pennsylvania: Lehigh University Art Galleries, 1986).

T. O'Conor Sloane, Jr.
1870–1963

Despite being a member of the Photo-Secession, the most advanced group of creative American photographers around 1900, little is known about Thomas O'Conor Sloane, Jr.

He was born in Brooklyn but apparently spent most of his life in Orange, New Jersey. Sloane was the son of an accomplished scientist and trained as an electrical engineer. He was photographing by the summer of 1894, at age fifteen, when he documented a weeklong cruise with his father on a sloop yacht on Long Island Sound. Pictures of this trip survive in a unique album compiled by Sloane, now at the Mystic Seaport Museum (Mystic, Connecticut).

Sloane was most active at the turn of the twentieth century. At this time reproductions of his work appeared in the *American Annual of Photography* and the monthlies *Photo Beacon* and *Photographic Times*. He exhibited his pictures in both this country and Europe. In 1900 he showed in photographic salons in Chicago and Philadelphia. His photographs were accepted by juries in London in 1901 and Turin, Italy, in 1902. He also exhibited in members' shows of his hometown Orange Camera Club and the prestigious Camera Club of New York. In 1902 Alfred Stieglitz included work by Sloane in the inaugural Photo-Secession exhibition, at New York's National Arts Club, a high honor.

Sloane was partial to landscape and nude subjects. He experimented with gum bichromate, a process that allowed heavy hand manipulation of the photographic image, and even penned a brief note on it for *Camera Notes* in January 1901.

After this date, Sloane all but disappeared in the photographic press, except for a portrait of him in the May 1932 issue of *Photo Miniature*. He died in 1963.

Louis F. Stephany
1873–1952

Louis F. Stephany was a leading figure in artistic photography in Pittsburgh at the beginning of the twentieth century. He worked for the Carnegie Steel Company.

Stephany first exhibited in the 1900 Pittsburgh Salon, where his print *The Last Load* received a prize. This image, of a haying scene, became his most well known and was reproduced in the *Photographic Times* in 1904. In 1902 he contributed an illustrated article on flower and fruit still lifes to the *American Annual of Photography*, in which he discussed lighting, backgrounds, and the proper apparatus for such work.

Stephany's greatest contributions came a few years later. In 1903 he helped establish and became the first director of the Camera Club of Pittsburgh, a small group devoted to artistic photography. In January 1904 he edited and published the first (and possibly only) issue of *Camera Topics*, as the journal of the club. This small, unillustrated publication gave a brief history of American pictorial photography, praised Alfred Stieglitz, and detailed club officers and meetings. Its handsome design and letterpress printing were inspired by Stieglitz's own publication *Camera Work*.

In the fall of 1903 Stephany visited Stieglitz in New York, and the two agreed to have their respective groups cosponsor an exhibition at the Carnegie Institute, Pittsburgh's leading art museum. "A Collection of American Pictorial Photographs," seen early the next year, featured work by Pittsburgh camera club members Charles K. Archer, Oscar C. Reiter, and Stephany, among others, and many prominent Photo-Secessionists. The show was well attended and accompanied by a deluxe catalogue illustrated with seven photogravures from *Camera Work*. Stephany himself became a member of the Secession but did not participate in any of its other exhibitions.

The last show known to include Stephany's work was the Capital Camera Club's 1905 annual exhibition, presented at the Corcoran Gallery of Art in Washington, D.C. Stephany died in 1952.

Alfred Stieglitz
1864–1946

Alfred Stieglitz is the fountainhead of American artistic photography. He produced iconic images, promoted the work of others, published periodicals, and ran galleries.

Stieglitz was born in Hoboken, New Jersey, but from the time he was seven lived primarily in New York City. In 1881 he went with his family to Europe and a few years later began studying photography in Berlin. He soon was writing technical articles for the photographic press and in 1887 won his first prize for a photograph. Stieglitz returned to America in 1890 and for the next five years helped run the Photochrome Engraving Company, where he learned about printing.

In 1891 he joined the Society of Amateur Photographers of New York, commencing a long period of activity with fellow camera workers. He edited the *American Amateur Photographer* for a few years and then helped found the Camera Club of New York in 1896. He presented a one-person exhibition of his work at the club in 1899 and founded and edited its quarterly *Camera Notes* (1897–1903).

Stieglitz organized and ran the Photo-Secession, an elite group of creative photographers, and its allied periodical and gallery. After the group's inaugural exhibition in 1902 he began publishing *Camera Work* (1903–17), the world's most beautiful magazine of photography. In 1905, with the help of Edward Steichen, he opened the Little Galleries of the Photo-Secession, later known as "291" for its address on Fifth Avenue. Here, Stieglitz presented not only the work of advanced pictorial photographers but also the then little-known art of such modern painters as Cézanne, Matisse, and Picasso. He was responsible for numerous large, museum-sponsored exhibitions of artistic photographs and was involved in the important Armory Show of 1913.

After closing "291" in 1917, he ran two additional galleries in New York. The first was the Intimate Gallery, in the late 1920s; the second was An American Place, from 1929 until his death in 1946. The exhibitions at both galleries focused on a small group of American modernist painters, including John Marin, Marsden Hartley, and

Georgia O'Keeffe, whom he married in 1924. During this time, Stieglitz was making both photographic portraits of O'Keeffe and a series of cloud pictures he termed *Equivalents*, two of his most important bodies of work.

Late in life he gifted his own photographs plus his collection of the work of others to the Metropolitan Museum of Art. After he died, Stieglitz's ashes were buried at Lake George, New York, where he and his family had summered much of his life.

Henry Troth
c. 1860–1945

Henry Troth, a member of a Quaker family of chemists, was a professional photographer in Philadelphia. He specialized in flower and landscape images, illustrating many publications. He also produced personal work that was included in many exhibitions of artistic photographs around the turn of the twentieth century.

Troth's creative work was exhibited in both the United States and Europe. He commenced showing in 1892 at exhibitions in Boston and Philadelphia. By the end of the decade his work was being accepted by juries in London, Glasgow, Paris, Brussels, and Hamburg. In 1897 he was honored with a one-person exhibition at the Camera Club of New York. Three years later F. Holland Day included prints by Troth in the important show "The New School of American Photography," seen in London and Paris. Alfred Stieglitz presented one of Troth's photographs in the inaugural exhibition of the Photo-Secession in 1902 but did not invite him to become a member of the group. In addition, Troth served on exhibition juries, most notably, the Philadelphia Photographic Salon in 1899.

Troth's images were widely seen in the photographic press, popular magazines, and books. Between about 1895 and 1905 his creative images appeared in such monthlies as the *American Amateur Photographer*, *Photo Beacon*, *Photo Era*, *Photo Miniature*, and *Photographic Times*. In 1897 Troth wrote a four-part article for the *Ladies' Home Journal* titled "Amateur Photography at its Best," illustrated with his own pictures of landscapes and wildflowers. His images appeared in three handsome books that were part of the back-to-nature

movement: J. P. Mowbray's *A Journey to Nature* (1902), Sidney Lanier's *Hymns of the Marshes* (1907), and Charles Francis Saunders's *A Window in Arcady* (1911).

Botany held sway for Troth, prompting him to make hundreds of straightforward photographs of flowers. These were used for the books *The Flower Finder*, *Nature's Garden*, *Phytogeographic Survey of North America*, and *Wild Flowers Worth Knowing*. He also supplied original photographs to the Botanical Section of the Academy of Natural Sciences of Philadelphia for their files.

Troth's last photographic byline appeared in the *American Annual of Photography 1910*, on an article he wrote on equipment. According to the *New York Times*, Henry Troth died in Philadelphia on April 25, 1945, at the age of 85. His frequently published life dates of 1863–1948 are incorrect.

———

"Henry Troth: Photographer, Co-Founder of Salon in Philadelphia, Was 85," *New York Times*, April 28, 1945, 15.

Doris Ulmann
1882–1934

Doris Ulmann photographed from the 1910s until her death, concentrating on portrait work. Her images of both well-known Americans and rural southern blacks were published in numerous books during her lifetime.

Ulmann was born into an affluent New York City family in 1882. She studied teacher training at the Ethical Culture School as well as psychology and law at Columbia University. Around 1910 Ulmann began studying photography with Clarence H. White, at both Columbia and the White School of Photography in New York. Between about 1915 and 1925 she went by the name Doris Jaeger, due to her marriage. When the White School moved to a new location in 1920, a one-person exhibition of her work inaugurated its gallery. By this time she was a member of the Pictorial Photographers of America (PPA), a group that included reproductions of her work in four of its annuals during the 1920s. In 1932 the PPA sponsored a traveling show of work by Imogen Cunningham, Laura Gilpin, and Ulmann.

Ulmann devoted herself to professional photography in 1918. She began making softly focused portraits in her living room of famous individuals in literature and the arts. Within the next decade, three deluxe, gravure-printed books of her portraits appeared, picturing the faculty of physicians and surgeons of Columbia University (1919), the medical faculty of Johns Hopkins University (1922), and American editors (1925).

In about 1925 Ulmann began to photograph rural folk along the East Coast. Initially, she worked in New England, concentrating on the Amish, Mennonite, and Shaker communities. After 1927 she traveled with folklorist John Jacob Niles to remote areas of the Appalachian Mountains, producing her best-known work there over the next several years. She also made portraits of the black residents of a South Carolina plantation; these were used to illustrate Julia Peterkin's 1933 book *Roll, Jordan, Roll*.

The next year Ulmann died at her New York City home.

———

David Featherstone, *Doris Ulmann: American Portraits* (Albuquerque: University of New Mexico Press, 1985).

Willard E. Worden
1868–1946

Willard E. Worden was a professional photographer in San Francisco for the first thirty years of the twentieth century. He turned his camera primarily on the city, especially Chinatown, and the landscape of the region.

Worden was born on November 20, 1868, in Philadelphia, where he studied painting as a young adult. In 1898 he enlisted in the infantry and was sent to the Philippines to fight in the Spanish-American War.

Worden returned to the United States devoted to photography, after using a small, personal camera during his time in the service. He moved to San Francisco in about 1900 and two years later established a photographic studio at the Cliff House, a prominent hotel perched on the edge of San Francisco Bay.

Worden's work was widely seen in the Bay Area over the next few decades. In 1911 he contributed an illustration to Paul Elder's deluxe book *California the Beautiful*, which combined rich, tipped-in reproductions with prose and verse. Worden's image pictured a swirling tide and seal-covered rocks in San Francisco Bay and was accompanied by a poem by Bret Harte. Four years later his work was included in the exhibition of artistic photographs displayed at San Francisco's Panama-Pacific International Exposition, a show organized by fellow San Francisco photographers Anne Brigman and Francis Bruguière.

Worden closed his studio in the early 1930s, after running it for thirty years. He died in obscurity in Palo Alto, California, on September 6, 1946, having willed his entire collection of negatives to Wells Fargo Bank, San Francisco.

Selected Bibliography

Adams, W. I. Lincoln, ed. *Sunlight and Shadow: A Book for Photographers, Amateur and Professional.* New York: Baker and Taylor, 1897.

Caffin, Charles H. *Photography as a Fine Art: The Achievements and Possibilities of Photographic Art in America.* New York: Doubleday, Page, 1901.

Emerson, Peter Henry. *Life and Landscape on the Norfolk Broads.* London: Sampson Low, Marston, Searle, and Rivington, 1886.

———. *Idyls of the Norfolk Broads.* London: Autotype Co., 1887 [portfolio].

———. *Pictures from Life in Field and Fen.* London: George Bell and Sons, 1887.

———. *Pictures of East Anglian Life.* London: Sampson Low, Marston, Searle, and Rivington, 1888.

———. *Naturalistic Photography for Students of the Art.* London: Sampson Low, Marston, Searle, and Rivington, 1889.

———. *Wild Life on a Tidal Water: The Adventures of a House-Boat and Her Crew.* London: Sampson Low, Marston, Searle, and Rivington, 1890.

———. *Pictures of East Anglian Life.* London: the author, 1890 [portfolio].

———. *The Death of Naturalistic Photography.* London: the author, 1890.

———. *On English Lagoons, Being an Account of the Voyage of Two Amateur Wherrymen on the Norfolk and Suffolk Rivers and Broads.* London: David Nutt, 1893.

———. *Marsh Leaves.* London: David Nutt, 1895.

———. "What Is a Naturalistic Photograph?" *American Annual of Photography 1895,* 122.

———. *Naturalistic Photography for Students of the Art.* 3rd ed. New York: Scoville and Adams, 1899.

———. "Bubbles." *American Amateur Photographer,* vol. 12 (October 1900): 465–70.

Handy, Ellen, et al. *Pictorial Effect/Naturalistic Vision: The Photographs and Theories of Henry Peach Robinson and Peter Henry Emerson.* Norfolk, Virginia: Chrysler Museum, 1994.

Hartmann, Sadakichi. *Landscape and Figure Composition.* New York: Baker and Taylor, 1910.

Hinton, A. Horsley. "Naturalism in Photography." *Camera Notes,* vol. 4 (October 1900): 83–91.

Lee, Mack, et al. *Naturalistic Photography, 1880 to 1920.* Winchester, Massachusetts: Lee Gallery, 1998.

McWilliam, Neil, and Veronica Sekules, eds. *Life and Landscape: P. H. Emerson: Art and Photography in East Anglia, 1885–1900.* Norwich, England: Sainsbury Centre for Visual Arts, University of East Anglia, 1986.

"Naturalistic Photography." *Wilson's Photographic Magazine,* vol. 32 (March 1895): 109–11.

Newhall, Nancy. *P. H. Emerson: The Fight for Photography as a Fine Art.* Millerton, New York: Aperture, 1975.

Panzer, Mary. *Philadelphia Naturalistic Photography, 1865–1906.* New Haven: Yale University Art Gallery, 1982.

Peterson, Christian A. "American Arts and Crafts: The Photograph Beautiful, 1895–1915." *History of Photography,* vol. 16 (Autumn 1992): 189–232.

———. *Index to the American Annual of Photography.* Minneapolis: the author, 1996.

Sawyer, George A. "Naturalistic Photography." *Photographic Times,* vol. 26 (June 1895): 358–59.

Stillman, W. J. "Naturalistic Photography: A Review of Dr. Emerson's Book on This Subject." *Photographic Times,* vol. 20 (May 9, 1890): 222–24; (May 16): 236–37; (May 23): 247–51.

Taylor, J. Traill. "Fuzzyness and Naturalism." *American Annual of Photography 1891,* 240–41.

Taylor, John. *The Old Order and the New: P. H. Emerson and Photography, 1885–1895.* Munich: Prestel, 2006.

Turner, Peter, and Richard Wood. *P. H. Emerson: Photographer of Norfolk.* Boston: David R. Godine, 1974.

Wright, Mabel Osgood. "Naturalism in Photography." *Photographic Times,* vol. 30 (October 1898): 434–35.

Index

This index includes only proper names. Numbers in *italics* refer to pages with illustrations.